PARANORMAL BERKSHIRE

ROBERT BARD

AMBERLEY

First published 2021

Amberley Publishing
The Hill, Stroud
Gloucestershire, GL5 4EP

www.amberley-books.com

British Library Cataloguing in Publication Data.
A catalogue record for this book is available from the British Library.

ISBN 978 1 4456 9589 1 (print)
ISBN 978 1 4456 9590 7 (ebook)

Typesetting by SJmagic DESIGN SERVICES, India.
Printed in Great Britain.

Contents

Introduction

In writing this book I was able to embark on a personal voyage of exploration of a subject that has always fascinated me. Several of my previous books have looked at gruesome and grisly subjects including lost and hidden graveyards, places of execution, and London's crypts and catacombs, so a venture into the world of the paranormal seemed a logical step. I have experienced several events that I would describe as paranormal. Once I saw my hat fly across the lounge late at night whilst watching television. I was stunned and froze trying to take in what I had just seen. The room was well lit and draft free. I left the hat on the floor and paced the take-off to landing distance, which was around 15 feet. To this day I still think about the incident and cannot find any rational explanation. In the writing of this book I hoped to visit the most documented sites and perhaps see or experience something for myself. Where possible I would interview those that might have seen or could shed some light on any ghostly activity. I also took to asking my friends and acquaintances the same question – 'have you ever seen a ghost?' The number of positive replies astounded me. More than half claimed to have either seen a ghost or had some paranormal experience.

In my search for the paranormal I decided to join the Ghost Club, which had in earlier days counted Charles Dickens as one of its members. Secondly, I spent an extended pre-Christmas Eve evening at the centre of everything paranormal: the churchyard at Borley in Essex, reputedly along with the now no longer standing Borley Rectory, one of the most haunted places in England. It was a completely clear, full, moonlit night when I pulled up in a narrow gravel layby outside the churchyard. The remote village of Borley has removed road signs that might lead people like myself to it, so satnav is an important ghost-hunting accessory. I walked quietly around the deserted graveyard snapping in groups of three shots to allow comparison should something appear in one or more of the pictures. I was aware that I was looking for 'orbs' – small, round, floating objects and unexplained shadows; blurs and figures in my photographs. Orbs, depending on whom you are inclined to believe, are either manifestations of spirit energy or impurities in the air captured by modern digital cameras. Having taken hundreds of random pictures in the graveyard there were a couple that made me pause for thought. Despite being in one of England's reputedly most haunted graveyards on a dark, crisp and very silent night in the middle of the Essex countryside, I desperately hoped something, anything, would happen, but I saw and felt nothing unusual.

As part of my quest to encounter the paranormal I joined twenty fellow members of the Ghost Club who were searching for reported phantoms at a place called High House on the banks of the River Thames in the shadow of the Tilbury Docks and Queen Elizabeth Bridge. High House was originally built between 1552 and 1559.

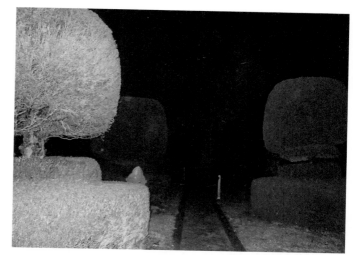

Borley churchyard footpath,
known for paranormal sightings.

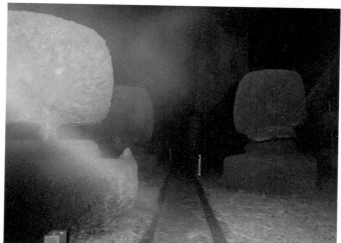

This picture was taken seconds
after the first, showing an
anomaly not visible at the time.

This picture was taken
immediately after the second.
No flash was used in any of the
photos.

We were briefed during the pre-hunt meeting in the ancient but highly modernised attached barn that we were looking for a phantom soldier and a little girl, both of whom had been witnessed on a number of occasions – the girl was said to appear in an upper window at the front of the house. This was high-tech spirit detection operation involving a planned thirty-minute observation in groups of four in various parts of the grounds. As the evening progressed, I was hoping something – anything – remained in a keen spirit of anticipation. Instruments flickered and lights lit up, but when the evening came to a close at 1 a.m. and all participants met back in the barn to report what, if anything, had been observed during the course of the hunt, disappointingly neither soldier nor little girl had chosen to make an appearance!

I have visited most of the sites in this book and where possible spoken to the occupants about their ghostly experiences. I have concentrated on the best-documented sites, and those I thought were the most worth visiting – either as places to visit in search of the paranormal or at the very least because they are pleasant hotels, pubs, or historic sites worth a visit in their own right. Windsor and Eton offered a high concentration of both historic and ghostly elements. For both Windsor and Eton, I have relied heavily on the excellent book by Brian Langston, *True Ghosts and Ghouls of Windsor & Eton.* Brian is also a member of the Ghost Club and was the former Assistant Chief Constable for Thames Valley Police, which gives, in my opinion, added authenticity to a number of sightings which I have referred to below as they involved members of the same police force. To get a real feel for Windsor I joined the Windsor Ghost Walk run by Andrew and his cast of actors and an actress dressed in the appropriate period costumes. It was enjoyable, informative and for a chilly and showery pre-corona lockdown February night, very well attended. The photographs are taken by myself unless otherwise stated.

'Orbs' captured at Hill House, in one of many dozens of photographs taken in the courtyard of the house where the phantom soldier had been spotted on a number of occasions.

Bisham

Bisham Abbey

Bisham Village, Marlow Road, Bisham, Marlow, SL7 1RR

Bisham Abbey is located close to Marlow, on the Berkshire and Buckinghamshire border and is said to be one of the most haunted houses in Britain. Access to the house, which is a sports centre, requires permission, but the grounds by the side of the River Thames are accessible. I was very kindly given permission to be shown around the abbey by the sports coordinator Aaron Jewell. On the mid-February day I visited the abbey and the nearby ancient church it was bright and sunny and the abbey looked anything but haunted. I was greeted by Jim O'Connor, who looks after maintenance at the abbey and has spent six years working both days and nights in the house – often alone. The obvious question was 'have you ever seen anything of a supernatural nature?' I awaited his reply in excited anticipation. If there was anything here Jim would have surely seen it. His reply was somewhat disappointing: 'Nothing! Yes, the house creaks and groans and makes noises – it is after all incredibly old – but no, I've never seen anything that couldn't be explained.' Jim's tour of the abbey was detailed and informative with information about where the hauntings were said to take place. As I was in the reception area about to leave, Wendy, who has worked in the office of the house for two years, introduced herself. Almost hopelessly I told her that there did not seem to be much of a paranormal nature going on. She replied that it was certainly not the case. She related several incidents that she and her co-workers had experienced or witnessed that could not possibly have any rational explanation. Firstly, there was the old Tudor table situated immediately by the staircase outside the Great Hall. She commented that almost on a weekly basis they would hear crashing glass coming from the base of the stairs next to the table and find broken glass on the table. Two other inexplicable events occurred in the Elizabeth Room located at the top of the stairs which leads into the hall. Wendy told me of locking doors that a short while after were found to be unlocked, and of an incident with a tray during a conference where a colleague bringing in refreshments tripped by the door and yet the tray fell without losing its contents.

The house was built around 1260 as a community house for the Knights Templar. During the sixteenth century it was bought by the Hoby family, who lived there until 1768. Lady Hoby was a friend of Elizabeth I who paid several visits to Bisham. It was during the Hoby ownership that the events took place that would lead to its most famous phantom returning. It seems that Lady Hoby was a strong, formidable and highly educated woman who wanted to prepare her children to take their places

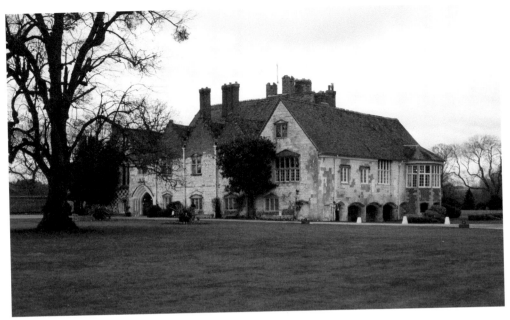

Bisham Abbey, believed to be one of the most haunted sites in Berkshire.

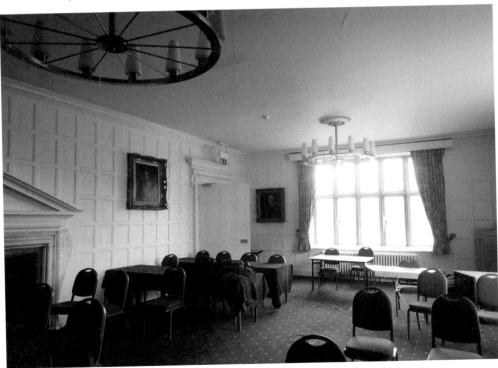

The Elizabeth Room, which was originally used as a council chamber by both Henry VIII and Elizabeth I. In the corner is a door leading to a small lobby with a spyhole looking down into the Great Hall. This room has been the scene of at least two inexplicable events in the last five years.

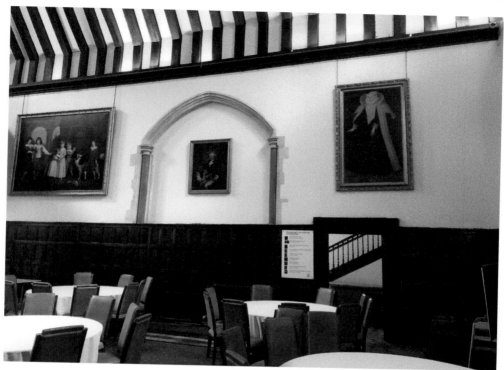

Above: The Great Hall where the portrait of Bisham's most famous phantom, Lady Hoby (1528–1609), is on display. Her ghost is said to haunt the Great Hall where her portrait (right), hangs.

Right: The haunted Tudor table from the old kitchen at the foot of the stairs leading to the Elizabeth Room at the top, both of which have been the source of several strange events.

in Elizabethan society. She and her first husband, Sir Thomas, had four children, and after his death she remarried twice more and had three or four more children. The story is that her son William, who is not known to history, was one of her children from her second marriage. He was academically slow and struggled to keep up with his lessons. Consequently, Lady Hoby would beat him as punishment. One day when he reputedly blotted his copybook, she beat him and tied him to a chair. Her other children were allowed to leave the classroom in the tower. William was told to rewrite his work. She slammed the door and locked it shut and went out riding. Whilst out she was greeted by a messenger sent by the Queen who asked her to come to Windsor Castle. She rode straight off and did not return for several days. Rather unbelievably she had completely forgotten about William still confined in the tower. On her return to Bisham her children ran out to meet her, except for William. Thinking that William was sulking she asked her housekeeper where he was. The housekeeper replied saying she thought he had gone with Lady Hoby. In a state of shock Lady Hoby ran to the tower but William had perished still tied to the chair in the classroom. Filled with guilt and remorse her phantom made its first appearance in the early 1600s wandering the grounds, moaning and wringing her hands.

As the whole ghost story hinges on the existence of this William, there is an interesting article which looks at the possibilities. It asks whether William really existed and is the story merely a fable. 'It is quite feasible to suppose that little William did exist, even though no definite record of him has been found. He does not appear in the Bisham baptismal registers, but both Hobys and Russells held other estates on which a son could have been born and christened. Not all records have survived from those far-off days not long after parish registers began (1538), and many children's entries were missed from the register at that time anyway. Dame Hoby would not even have had to have instigated a cover-up to hide her son's very existence as some have suggested.'

The writer observes that such was the child mortality rate 300 years ago that a deceased child would have left relatively little trace but that 'proof' of William's existence may be provided by an event in the abbey that took place in 1840. The article refers to the copybooks discovered by builders under the floorboards that were seen by Mrs Vansittart who 'later remembered, had a blot on nearly every page' and bore, she believed, the name of William Hoby. 'Convenient though the loss of the copybooks were, the fact that they existed is beyond doubt … the events were recorded in detail by Mrs. Vansittart shortly after they happened. It is Mrs Vansittart's memory, however, that we might question. After all she only ever said that she thought the name on the blotted books had been "William Hoby". Early versions of the legend do not mention a Christian name for the lad. It, therefore, seems probable that the name William stems from this discovery in the mid nineteenth century. When given a surname the boy is always a Hoby, yet the fact that William was said to be Lady Hoby's youngest son totally contradicts this. Her youngest son was a Russell and her youngest Hoby son was most definitely Thomas Posthumous, born after his father's death. It is possible that the boy's surname may have been transferred direct from his mother who is always referred to as Lady Hoby rather than Lady Russell. Though it was not unusual, her actual youngest son, Francis Russell, did in fact die at a young age in unknown circumstances. Could he have been the so called "William"?'

The house was finally sold after the death of Sir Henry Vansittart-Neale's daughter, Phyllis, in 1958. Both her heirs, her nephews, had been killed in the Second World War,

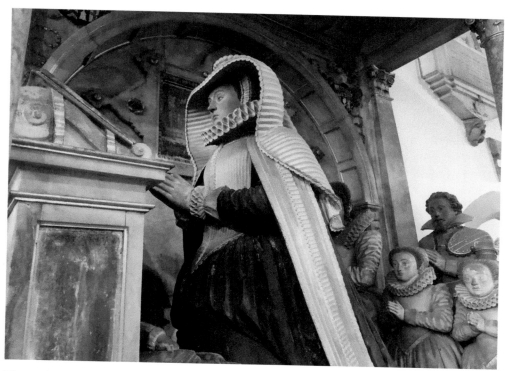

The Hoby memorial in Bisham Church, designed by Lady Hoby during her own lifetime. She died in her nineties in 1609. Behind her are her children from two marriages who died young. She is Bisham's most famous phantom.

The tower above is where Lady Hoby's young son William is alleged to have been tied up, beaten, and where he perished. A light has been seen in the empty Tower Room.

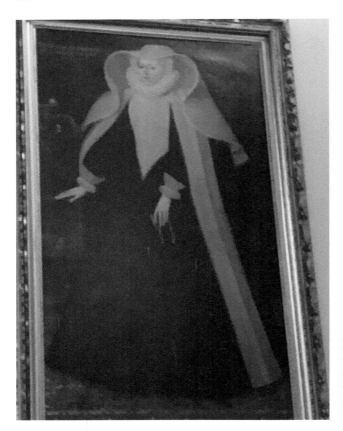

Lady Hoby's portrait now in the Great Hall. She appeared to Admiral Edward Vansittart, when she stepped down from her portrait to stand beside him.

and the Sports Council took on the estate as a memorial to them. The Hoby memorial in Bisham Church was designed by herself!

Up until 1936, Lady Hoby had apparently materialised at Bisham during every coronation since at least that of Charles I.[1]

Lady Hoby has been quite prolific in some of her appearances. She has torn curtains from four-poster beds, where guests were sleeping, thrown things around rooms, and threatened to strike a man bald! It is reported that she often materialises in the negative, with black face and white clothes. In recent years it is merely a sobbing that is heard, or a light is seen in the empty Tower Room. She was once seen by some young boys in a boat down by the river, and some even believe she is responsible for the mists which often envelope the abbey, which are said to draw passers-by into the depths of the Thames.

She has been seen with a miraculous fountain floating before her and she tries constantly to wash bloodstains from her hands. She also appears in the Tower Room

1. (See note from Emily Climenson in J. Berks Archaeol & Arch Soc vol 12 1906–7 p60–61). Dormer points out the lack of evidence, including there being no child of that name. (See his letter BRO D/EX73/4/2/16). She is said to haunt the house leading to a profitable sideline in Ghost Tours. http://www.maidenheadcivicsoc.org.uk/group/2086/Projects/Documents/Bisham%20Trail.pd

at the time of a coronation when she shows her guilt at choosing her monarch over her son.

Probably the most interesting appearance was to Admiral Vansittart who wrote, 'We had finished playing and my brother had gone to bed. I stayed some time with my back to the wall turning over the day in my mind. Minutes passed. I suddenly realised the presence of someone standing behind me. I tore round and it was Dame Hoby.' He then noticed that the painting of Lady Hoby was there but the image of Lady Hoby was missing. There are a number of interesting reports that stand out from the more usual, often repeated hauntings. Nell Rose on her blog recounting the Bisham hauntings relates 'I remember a story that my mother told me about the Second World War. She was a Sergeant in the WAAF, and worked mainly as a telephone operator. She was a practical woman who had no time for ghostly tales. Being given what she called the graveyard shift, she walked through the abbey to get to her station. The windows didn't have curtains at the time, and from where she was positioned, she could see out over the grounds, and in the distance the river glowed faintly in the moonlight. One night as she took her seat, she noticed out of the corner of her eye a mist coming in over the grounds. She took no notice and carried on with her work. Suddenly she heard an intake of breath and looked towards the other girl who was sharing the shift. The girl was pointing towards the window. Outside the mist had taken on a shape. The form slowly glided by the large window, and to my mother's eye she saw a woman take shape, her hands out in front of her. The ghostly woman drifted away across the fields and disappeared. In the last few months of the War, my mother had been privileged to see the ghost of the grey lady. When I asked her what happened, she had a faraway look in her eye and said, "We saw something that night and it made the hairs stand up on the back of my neck." I don't believe in ghosts, but at that moment I wanted to walk out of the door and get a strong drink.'

Further accounts come in the form that in more recent years two boys on their way back from a fishing trip at dusk were scared when they saw a boat by the bank of the river. In it was an old woman, huddled in her black cloak. Another came before the Henley Regatta when Bisham Abbey was crowded with visitors getting ready for the event. Whilst getting ready to go to sleep one young man in the library, during the night, felt someone touching his hair, and waking up abruptly he saw to his horror the spectre of Dame Hoby. Softly she spoke these words to the terrified boy: 'Young man, if I touch thee, thou will be bald'! One might possibly put this rather bizarre report down to a dream. A young girl staying at the abbey went to bed, and whilst lying in bed reading, she noticed that her dog was becoming agitated. His hackles were rising, and he leapt of the bed with a yelp and ran from the room. She suddenly noticed that her watch on the bedside table had risen into the air and shot across the room. Then sheet music was thrown about, and her vanity case was knocked over. The curtains of the bed were then wrenched open and standing there in front of her was a woman wearing an old-fashioned nightgown. In a state of shock, the girl ran from the room and downstairs, where after she told her story, she was shown the portrait of Lady Hoby. The girl recognised her from the sighting.

Another report of a more personal nature comes from a woman who reported the following: 'Living in the area all my life, I have heard this ghostly tale many times over the years. In fact, Elizabeth's hauntings are said to be a lot farther afield than just Bisham Abbey. There is an alley in Marlow called Seven Corner Alley. I think it must have had a proper name at one stage, but all the locals know it as the above. It's

a spooky alley I can tell you, and not one for walking alone in the dark. As you walk through it seems to get narrower and narrower, and right in the middle, with a tall wall to one side and a building to the other, there is a particular spot that is said to show, in certain conditions, a large handprint fused in the wall. As children we would always look for it, but I could never see it. Then one night, walking through with my friends, one of them yelled, 'I just saw the handprint, there!' And he pointed to the wall. And for just a second, I thought I could see a shadow. A shadow of a hand dripping water. We ran and never looked back.' For a fascinating history of Bisham and its church I highly recommend *A History Trail of Bisham Abbey and All Saints Church, Bisham* by Ann Darracott, available online.[2]

2. http://www.maidenheadcivicsoc.org.uk/group/2086/Projects/Documents/Bisham%20Trail. pdf

Combe

Combe Gibbet

Southwest of Newbury, reached by minor roads past the village of Combe. Nearest A roads: A336, A334, A4

Gibbets were where the executed corpses of criminals were bound in chains and hung until they rotted. It denied the criminal a Christian burial and acted as a visible warning to passers-by. During the eighteenth century gibbets were a feature along what is now the A4, due to the prevalence of highwaymen. Combe Gibbet stands just inside Berkshire on the Berkshire-Hampshire border.

The sunny pre-lockdown day I and a friend visited Combe Gibbet it was difficult to appreciate the grim nature of the structure. On walking around a quarter of a mile to the west of the gibbet on a gravelled, pot-holed, water-filled trackway, we came to the area to the right of the track where it forks, and where the fateful events took place on 23 February 1676 when a farm labourer named George Bromham and an attractive widow named Dorothy Newman murdered George's wife and children by drowning them in Wigmoreash Pond, which later became known as 'Murderer's Pool'. The idea was to murder George's wife Martha who brought George his lunch daily to the area where he worked near where the gibbet is now. Unfortunately, George's small son had followed his mother Martha up the hill. Dorothy, to dispose of a witness, grabbed the boy and drowned him in the nearby dew pond. The atmosphere was quiet, peaceful, subdued and it was easy to imagine the events that took place there around 350 years ago, where the couple believed that nobody could possibly have witnessed their actions. Both stood trial for murder at the Winchester Assizes The record of the trial is to be found in the *Western Gaol Book*.[3]

Versions of events differ but one account was related in person to a correspondent of *Notes and Queries* in 1868 by Mrs Piper, who lived at Gore End, a remote hamlet around a mile from East Woodhay. She was more than seventy years old and had heard about the events from her own mother, who lived to a similar age. The story must have been told to her mother, and it may therefore have become garbled over

3. Western Circuit Gaol Book, XXII–XXIX Charles II, chapter XXVIII Ch.II, in Winchester Library

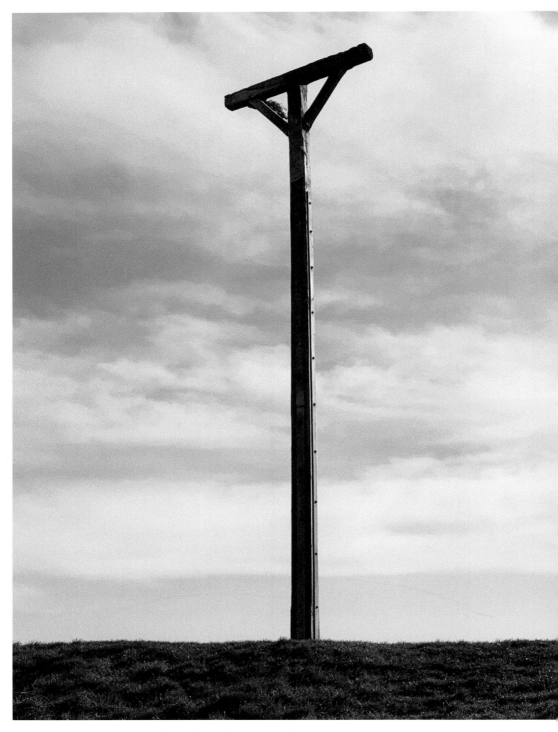

The gibbet on which the bodies of George and Dorothy were hanged, one on each side, on 6 March 1676. The area around the gibbet is meant to be haunted by their ghosts.

This lonely, often marshy, pathway, Wigmoreash Drove, passes behind the gibbet, and, towards the west, approximately a quarter of a mile further on, passes Wigmoreash Pond, referred to as 'Murderer's Pool'.

time, though it feels plausible in parts, not least because the accused woman is referred to as 'Doll', a common contraction of Dorothy. Mrs Piper began:

> George was a carrier, who lived at Gore End ... he had a wife and child and travelled daily between Woodhay and Combe. Doll was a widow, who lived at Combe with her two children, boys; and George was in the habit of meeting her during his stay at Combe and had long carried on an improper connection with her. One day George induced his wife and child to accompany him on his journey to Combe, and soon after leaving their cottage, he murdered his wife, stuffing her head into a hornet's nest, for the purpose of making it appear that she had been stung to death. Continuing his journey, he threw her child into a pond.

It was evening when George reached Combe, and he told Doll what he had done. Her two sons, who worked as ploughboys on a nearby farm, were asleep in the same room, and suddenly George was afraid that they had stirred and overheard him. He suggested to Doll that they should be murdered as well, but she assured him all was fine. In fact, they were awake and the next morning told their employer what had happened. They continued ploughing all day, while a constable was fetched from

'Gibbet Barn', where the two bodies were laid out at the back of the Crown and Garter Inn. The barn is said to be haunted by the sound of a sobbing male voice.

Newbury. That evening, Mrs Piper said, their mother tried to kill them with a meal of poisoned pancakes, but they were on their guard. During the night the constable arrested George Bromham and Dorothy Newman.

The bodies were hung 'in chaynes' on the double gibbet, near where the crime was committed. The gibbet sits on the top of a prehistoric long barrow. The two bodies were brought from Winchester back to the delightfully named Inkpen and laid out in the barn at the back of the Crown and Garter Inn, where they were measured up by the local blacksmith and fitted in their 'chaynes'. The barn subsequently became a tourist attraction and was renamed 'Gibbet Barn' by the commercially savvy landlord. The bodies of George and Dorothy were hung on Combe Gibbet on 6 March 1676, one on each side of the gibbet.[4]

The original gibbet lasted an unknown length of time, but the second was erected in 1850 to replace the rotted original. The present gibbet was re-erected on 1 May 1979.[5] The area around it is meant to be haunted by the spirits of George and Dorothy who it is said 'are still seen around the scene of their hilltop demise'. The barn where the bodies were placed is said to be haunted by the sound of a male voice crying – possibly George bemoaning his fate.

4. https://www.adkinshistory.com/newsletters/newsletter-56/
5. https://www.hungerfordvirtualmuseum.co.uk/index.php/8-places/875-black-legend

Combe Manor

Combe, Berkshire, RG17 9EJ

Combe Manor was originally a priory with an intriguing history. Charles II brought Nell Gwyn here. It is now a family-owned country house hotel specialising in exquisite weddings. Apparitions in 'crinoline dress' have been witnessed in the gardens, and nuns chanting are amongst the audible phenomena. Sometime in the early twentieth century a small skeleton was apparently uncovered underneath the stairs.

I asked Sybille Russell, owner of Combe Manor, if she was aware of any paranormal activity. She replied that 'there are some old folk-lore tales of sightings back in the mid-twentieth century but since my father-in-law bought Combe Manor in 1966 there has been no paranormal activities here'.

Datchet

The Royal Stag

The Green, Datchet, Slough, SL3 9EH

The Royal Stag in Datchet lies a short distance from Windsor and boasts a very unusual form of phantom that the pub proudly promotes. On the day I visited, the gentleman behind the bar was very forthcoming about the handprint that mysteriously appears on the glass panel which was directly behind the table I had chosen for lunch. I asked him firstly, does it really appear? Isn't it some deformity in the glass pane? He was adamant that not only did it appear – for some reason only after dark – but he had actually seen it himself.

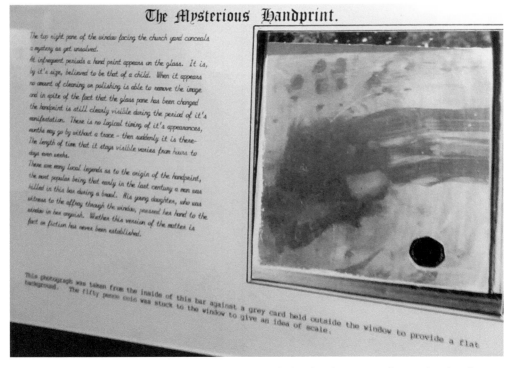

The pub wall literature along with a picture of the handprint attributes the hand to a nineteenth-century child who witnessed a bar brawl. The photograph was taken by a local in 1979.

The handprint of a small child who froze to death outside the pub appears on the outside of the window when it becomes covered in ice. It is the upper right pane in the photo. A tour guide reported seeing the hand along with fifty-three other people in February 2000. The bartender also claimed he had seen it.

The pub backs onto a churchyard, adding atmosphere to the inexplicable handprint.

One version of events says that 'a tragic tale has left a very visible imprint on the Royal Stag at Datchet.' According to the story, sometime during the Victorian era a labourer and his son stopped at the inn on a particularly bleak winter's day. Whilst the father went inside the pub to partake in some liquid refreshment, his son played outside. Gradually the cold began to take its toll on the youngster, so he went to the

People sitting in the bar have seen glass mugs hanging on hooks moved upright and the fire blow up as if giant bellows were at work.

window to attract his father's attention. Unfortunately, the man was having too good a time with his beer and the company to notice his son. The desperate child pressed his hand against the window in an attempt to draw notice to his plight, but the cold had already dealt its cruel hand – the boy collapsed in the snow and perished, leaving a solitary handprint on the glass. From time to time, a small handprint is said to appear on a window.'

Jeff Nicholls in his book *Our Mysterious Shire* relates that he was a cynic regarding the authenticity of the photograph until in April 1984 he received a phone call from the Stag landlord telling him the hand was visible. 'I borrowed a camera and rushed off to the pub. It was there, quite clearly. I cleaned the window from the inside whilst a friend, who thought nothing of the supernatural, cleaned the outside, then I took thirty-six photographs, some from inside and some from outside. Only one print came out; photography is not one of my strong points. A local newspaper photographer developed the film. Mine was the first successful attempt to photograph the print for five years.' The picture he took was like that taken in 1979. He also comments that 'when the photograph was left in the bar one night, it was discovered the following morning that the glasses and bottles had been smashed. People sitting in the bar have seen glass mugs hanging on hooks moved upright and the fire blow up as if giant bellows were at work. Footsteps from above have been heard by people downstairs, although people upstairs could see no one in the passage from where the noise was coming. Mumbling sounds are heard in the cellar which contains a tombstone of William Herbert found during clearing work in 1966. The slab is said to return to the

cellar when removed. A bedroom has been the focal point of controversy. One person who slept there felt a presence pushing down on him in the night and words like "stop it" being spoken. Something similar has been experienced by one of the landlord's family, who one night had a nightmare of being pushed down by a hippopotamus. The landlord recalls waking early one morning to see an elderly man in his bedroom. He rubbed his eyes and looked again, and a man was still there. When he got up and moved towards him, he vanished, but the landlord remembers he had grey hair and a large, hooked nose. A woman babysitting one night heard the toilet flush. Thinking it to be one of the children, she got up to see, but they were sound asleep. When she returned to the lounge, she heard the toilet flush again. Believing she was being messed about by mischievous children, she took her newspaper and went to their room. Once again, they were tucked up, asleep. She sat and read the paper, not to be caught again. While she sat there, the toilet flushed twice, but the children did not stir from their slumbers. All these stories about one place, occurring over a short period of time and experienced by various customers and landlords, seem hard to believe, so in May 1984 they were put to the test. A small group of us wanted to try to re-enact the night when the photograph was left in a bar. We placed the original photo in the bar, something that had been forbidden since the night of destruction five years earlier. Alongside it we placed mine and also brought the tombstone up from the cellar. The stage being set, we sat back and waited. Our stay that night was uneventful, and the pub failed to live up to its reputation. We saw nothing and the microphones heard nothing; the handprint failed to appear, and the tombstone remained where it was placed. Since then the print has appeared faintly, but nothing else unusual has happened.'

It would be interesting to know what exactly causes what appears to be a handprint!

Henley-on-Thames

Little Angel Public House

Remenham Lane, Henley-on-Thames, RG9 2LS

The ghost of Mary Blandy is thought to haunt both the Little Angel and the grounds of Park Place. She was an attractive local thirty-two-year-old woman from Henley – with a large dowry. When her father died suddenly in 1752, it was widely believed that she had poisoned him because he would not allow her fiancé, the Hon. William Cranston, to enter their house. The two had been lovers for six years, often meeting along 'Miss Blandy's Walk' at Park Place, but Cranston was found to be already married with a child. It is said that he sent Mary some arsenic to administer to her

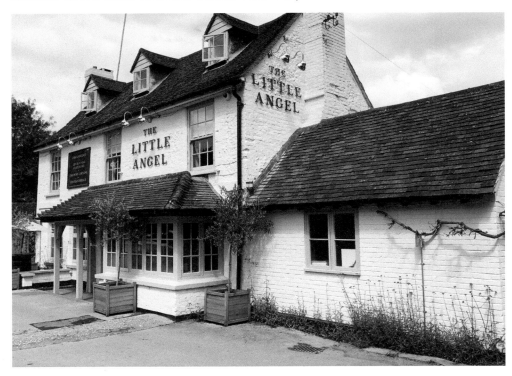

A ghost upstairs tramps around slamming doors. There is an eerie rapping at the front door and the spirit of a hysterical lady has been seen sitting on a couch.

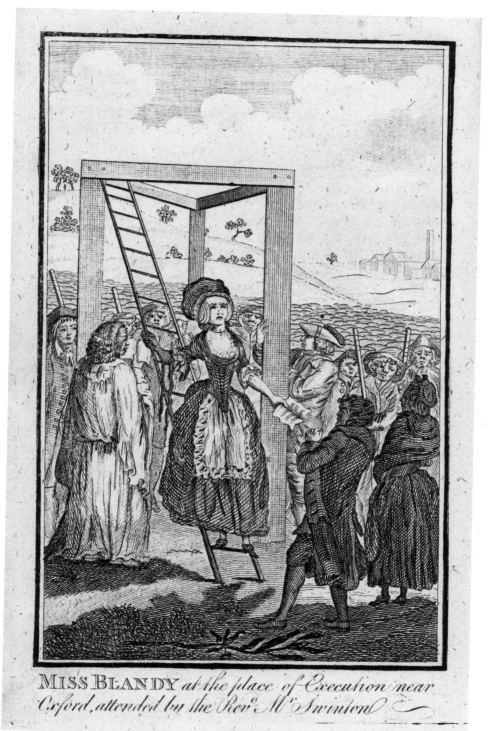

MISS BLANDY *at the place of Execution near Oxford, attended by the Rev.* M.r *Swinton*

The execution of Miss Mary Blandy, for the murder of her father, near Oxford on 6 April 1752.

father while he was ill. After the latter's death, Miss Blandy was detained in her room; but, on finding the door open, she went for a walk around Henley. The townsfolk were not happy and chased her over the bridge into Berkshire where she took refuge with her friend, Mrs Davis, the landlady of the Little Angel. After Mary was finally convicted, her last request was that, when she was hanged, for the sake of decency, she should not be hoisted too high!

A former innkeeper of the Little Angel alleges that for the first two and a half years of their tenure (since 1952) they had a ghost upstairs which tramped around slamming doors. Perhaps more easily associated with Mary was the eerie rapping at the front door and, on occasion, the spirit of a hysterical lady seen sitting on a couch.

Colnbrook

The Ostrich

High Street, Colnbrook, Slough, SL3 0JZ

This twelfth-century inn is a pleasant surprise located in a hidden part of ancient England in the shadow of Heathrow Airport. The sunny but cold February day I visited I was shown around by Liam. It is possible that up to sixty people had been murdered here in the fourteenth century, slaughtered in their sleep by the innkeeper, a man named Jarman, assisted by his wife. The couple put a trapdoor in the floorboard of an upstairs bedroom and by means of a lever, tipped the victims into a vat of boiling liquid placed directly below while they slept. Jarman and his wife would steal their money and sell their horses. Room 11 is where the strangers were sent to their deaths. According to Liam, the location of the trapdoor was where the bathroom is now located. The duo were ultimately caught and hanged for robbery and murder and since then, employees and visitors have reported sudden temperature drops, strange noises, voices and sightings of ghostly figures.

I asked Liam if he or the staff had ever seen anything that could be described as paranormal. He said there had been incidents where items and glasses had moved, but he had not actually seen anything. There have been several reported sightings of a Victorian lady haunting the upstairs corridor of the inn.

This twelfth-century inn has several phantoms and there have been reported sightings of a Victorian lady haunting the upstairs corridor.

One 14th-century landlord, Jarman of the
Ostrich Inn, installed a large
trap door under the bed in the best bedroom
located immediately above the inn's kitchen.
The bed was fixed to the trap door and the mattress
securely attached to the bedstead, so that when
two retaining iron pins were removed from
below in the small hours of the morning,
the sleeping guest was neatly decanted
into a boiling cauldron.
In this way more than 60 of his richer guests
were murdered silently and with no bloodshed.
Their bodies were
then disposed of in the River Colne.
The murder of a wealthy
clothier, Olde Cole or Thomas of Reading,
proved to be Jarman's undoing in that
he failed to get rid
of Cole's horse, leading to his confessing.
Jarman and his wife were
hanged for robbery and murder.

A description of the events that took place at the Ostrich Inn in the fourteenth century.

Room 11, the haunted bedroom where employees and visitors have reported sudden temperature drops, strange noises, voices and sightings of ghostly figures.

The inn retains many of its ancient features.

Above: A guest had been washing her hands when she turned to see a woman in full Victorian dress standing a few feet from her, before fading away.

Left: Apparitions have been seen in the corridors.

An interesting article on the *Newshopper* website dating back to 2001 relates the following:

Over the years there have been a catalogue of odd occurrences at the inn. Specialist investigators have recorded high readings of paranormal activity in parts of the building and long-standing members of staff claim to have seen apparitions wandering around the corridors. But reports of strange sightings and noises have become more frequent in the last six months since the High Street was dug up to lay down speed humps. Mark Bourne said: 'I never used to believe in ghosts but now I'm not so sure. I haven't seen anything myself but there have been an awful lot of unexplained occurrences here in the last few months.

Live-in staff have left a room locked but have come back to find the door wide open with lights and other electrical appliances switched on. Others say they have seen wooden shutters moving by themselves and strange noises can be heard in parts of the building that are no longer used. A member of staff who has worked here for 25 years once saw a black figure behind her boss as she was speaking to him. Customers have also witnessed strange phenomenon at the inn. There was one incident a few months ago when one of our regulars went to the ladies. She came back shaking and ashen faced. She had been washing her hands when she turned to see a woman in full Victorian dress standing a few feet away.

The disturbances have become more frequent since the council dug up the High Street to put speed humps down. I don't know what or who they disturbed while they were digging but it has definitely made this place a lot livelier.'

Bray

Oakley Court

Bray, Windsor, SL4 5UR

Oakley Court is the archetypal Gothic-looking mansion. Tales of the paranormal that surround it made a visit seem intimidating. Located 2 miles from Windsor, near the racecourse, it is now a four-star hotel with a justified reputation for its afternoon teas. The well-manicured grounds that front the River Thames hardly emanate the sense of evil that is said to exist here. On the day of my visit, in early, chilly February, the house exuded a warm, welcoming atmosphere.

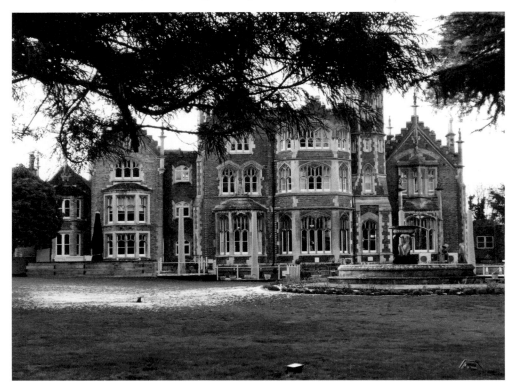

A number of ghostly hooded figures have been seen walking the grounds of Oakley Court. In more modern times it has been used as the location for a number of horror movies.

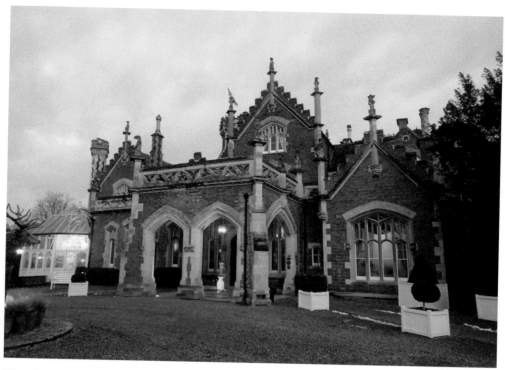

The ghost of a man standing in the drive on what was once the weighbridge of the estate has been seen and recognised as the once estate manager who was 6' 4" tall. He is wearing a wide-brimmed hat, long, black, caped coat, and long boots. He had a drawn face with a long very thin, crooked nose and eyes like steel.

Remarkably little is known about the property even though it was built over 120 years ago. It is situated along a stretch of the River Thames known as Water Oakley. The court was originally built in 1859 for Sir Richard Hall-Say and legend has it that he built it in the style of a French chateau to comfort his homesick young French wife. In more modern times it has been used as the location of a number of horror movies.

The court has a reputation for being 'evil', and several accidental drownings have occurred over the past thirty years. One such tragic story involves that of a woman named Penelope Gallerneault. The following full exchange is available on http://www.hauntedisland.co.uk/huanted-houses/oakley-court-berkshire, which I have abbreviated.

Mrs Penelope Gallerneault, twenty-six, lived in a flat in the Victorian Gothic country house of Oakley Court. The family were warned by friends before they moved in that the place was spooky and had previous history of accidents involving death by drowning. In the three years that they were there, she, her husband and children suffered many tragedies. The horror began in the summer of 1972. 'I started to see people walking in the grounds wearing hoods,' she says. In December her two-year-old son, William, died. Mrs Gallerneault was running him a bath when the phone went. When she returned he was floating in the water. 'I realize that many people might try to blame me for being careless, but that is just not the case.' A second tragedy struck the family when her second son Edward, who was just two, was left

Several ghostly hooded figures have been seen walking the grounds of Oakley Court. The atmosphere has been said to be so oppressive that several people have committed suicide in the Thames.

in his playpen in the grounds. Somehow, he got out, toddled down to the river, fell in and drowned.

Mrs Gallerneault said, 'The house has an aura of evil and I could never go back there.' The Revd Sebastian Jones, curate of St Michael's Church, Bray, added, 'Oakley Court is definitely "spooky" and I would not want to stay there myself. Evil can generate evil, and the grounds would be an ideal place to practise black magic.' The police, called in at every stage, are mystified too. A senior policeman said, 'There have been some strange happenings at the house, which have never been explained. We made regular patrols after complaints about witches, and things seem to have quietened down now. In the 1950s, the place was left derelict for many years. The atmosphere around the building apparently became so oppressive that it caused several people to commit suicide in the Thames.'

Another comment comes from Kerry Richard who in 2012 wrote the following:

'My father was involved with the restoration of Oakley Court during the 1970s. My sister and I also worked there briefly. During these years, a sceptic like me was convinced this place is haunted. At this time in the '70s I knew of the drownings and had spent time working along with my father during holidays. It really was spooky, the architecture, the tower, and gargoyles. My father came home on a few occasions with terror on his face, with honest accounts of scary goings-on, during the days and dark nights, glasses smashing, double doors opening, in front of him, people walking around (it was an empty building site), and other oddities like continuous electrical

faults, kettles boiling, and all sorts of mis-measurements, things not fitting after being re-measured countless times … bad workmanship? The nightwatchmen (who subsequently fell through the roof) heard many times people marching on the roof? and figures walking around the grounds. Whilst on reception at the hotel, my sister and a colleague heard the billiard balls "break shot", only to go into the room to find the balls stationary, and in formation on their spots.'

'It has a wonderful history, and is a beautiful building to look at, but it gives me the creeps'!

Jan Spicer in 2016 wrote, 'I am the Aunt for Robert, Blair, William and Edward and Penny's younger sister. I lived at Oakley Court at the same time as my sister and her family but in a different property… I saw only one ghost in the time I lived there; it was a man standing in the drive on what was once the weighbridge of the estate. I told the elderly gentleman, John, who had lived there since he was thirteen what I had seen and described the person who blocked my path, literally. He recognised him as the once estate manager who was a hard, cruel man. I can still describe this ghost. He was approximately 6' 4" tall wearing a wide-brimmed hat, long, black coat belted with a cape top, and long boots. He had a drawn face with a long, very thin, crooked nose and eyes like steel.

I was rushing down the drive on my way home and was worried because I was late. By the time I realised this person was in front of me it was too late, and I walked through him. I will always remember the cold shudder I experienced which lasted a long time. When I got home to my parents' house in Bray, I was still freezing cold even though it was a hot balmy summer evening and I had run all the way after my experience. Before this experience I was never afraid to walk around the grounds after dark. It was a creepy place, but I would not say it was evil. Remember, only the living can hurt you!

Robert Lucas, who once lived on the property, writes that he 'did indeed see a lady in white who used to chase me from room to room but have always thought I was dreaming'.

Several ghostly hooded figures have been seen walking the grounds of Oakley Court.

A receptionist, her sister and a colleague heard billiard balls being played only to go into the room to find the balls stationary and still in formation.

Donnington

Donnington Castle

Donnington, West Berkshire, RG14 2LE

Built in 1386, Donnington has several ghosts. It was more or less destroyed during the English Civil War. It is currently maintained by English Heritage and is a scheduled ancient monument free to visit and generally open during daylight hours. It is said to be one of the most haunted places in Berkshire.

The ghostly form of a 'Green Lady' has also been seen by the castle gates. The ghost is said to ask visitors why the gates are closed, before suddenly disappearing.

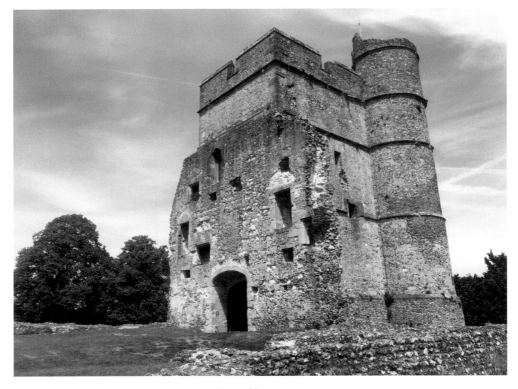

Donnington Castle lays claim to a number of hauntings.

A phantom dog was seen by visitors running from the castle towards the woods only to vanish before reaching the treeline.

The gatehouse itself is home to the ghost of a guard who appears in solid form and suddenly vanishes. The guard's ghost has been seen on both floors of the gatehouse and he is often mistaken for a guide in period dress.

A group of young campers witnessed the apparition of an elderly Royalist soldier with a young woman in a headlock, pulling her hair. Alarmed by this vision one of the campers shouted out at the Royalist cavalier to 'leave her alone'. The phantom soldier then growled loudly and carried on pulling his victim's hair. When the startled group approached the apparition, the soldier stood back and let out another almighty growl and both figures completely vanished.

A ghostly re-enactment of a skirmish between a Royalist cavalry patrol from the castle and a superior Parliamentary force from the town of Donnington was reported in Love Lane.

There have also been reports of the apparition of a white dog running from the castle towards the woods only to vanish before reaching the treeline! Visitors have also seen the ghosts of English Civil War soldiers and on at least one occasion a ghostly firefight has been witnessed between Royalist and Parliamentarian spectres! The Berkshire Paranormal Society have told me that for paranormal activity, both castle and parklands surrounding are quite active and it's one of their favourite sites.

Nearby is another related haunted site, that of Shefford Woodlands. This village was the home of Mother Barnes, the midwife who was called to attend the birth at Littlecote House 8 miles away. This is where 'Wild' Will Darrell (see Littlecote House)

Above left: The gatehouse itself is home to the ghost of a guard who appears in solid form and suddenly vanishes. The guard's ghost has been seen on both floors of the gatehouse and is often mistaken for a guide in period dress.

Above right: The guardhouse where the ghostly form of the 'Green Lady' has also been seen. The ghost is said to ask visitors why the gates are closed, before suddenly disappearing.

was killed in a fall when a vision of a burning baby frightened his horse. His mounted ghost, with severed head hanging gruesomely, reputedly still appears at the spot where he died. It has since become known as 'Darrell's Stile', at the point where the Hungerford-Wantage road crosses the old Ermine Way.

Eton

Eton lies a short bridge and walking distance from Windsor and has more than its fair share of phantoms and paranormal manifestations. I owe much to Brian Langston and his excellent book *True Ghosts and Ghouls of Windsor & Eton* for accounts of many of the Eton and Windsor hauntings. He evocatively describes Eton High Street, the scene of so much paranormal activity:

> Dominated by the stunning architecture of Eton College since 1440, this quiet town has been the focus of many awe-inspiring events. In 1537, escorted by the future 'Bloody' Mary as chief mourner, the funeral procession of Queen Jane Seymour passed down Eton High Street and rattled over the old wooden bridge before being taken into her tomb in St George's Chapel ... just a decade later, the body of Henry VIII was to pass down the same route on his journey to join the woman he married just eleven days after executing Anne Boleyn. History and bloodshed is never far away in Eton and it has a wealth of reported supernatural occurrences over the centuries. Indeed, some of England's earliest ghost stories have their origins in these picturesque buildings.

Langston reports that a shrouded figure 'has been seen on several occasions around the grounds and playing fields of Eton wearing a black cloak and a wide-brimmed hat'. Two sisters saw the same figure in Eton High Street; they thought they saw 'someone in fancy

Eton Chapel is haunted by a pair of figures that appeared unexpectedly in a photograph taken by an Eton housemaster in the 1950s.

dress' approaching them until the figure turned into a doorway and disappeared. When they reached the doorway, they found that it had been bricked up and there was no sign of the ghostly cloaked figure. A well-known and seemingly inexplicable event occurred in the Eton College Chapel in the High Street and the scene of one of the most famous photographs in which a phantom mysteriously appeared in a photograph, but was not seen by the photographer at the time. In the mid-1950s one of the Eton schoolmasters and a keen amateur photographer was taking photographs inside the chapel. He took a photo from the organ loft towards the altar at the east window only to find when it was developed that there were two shadowy figures in the print. The figures appeared to be an elderly couple looking at the altar with their backs to his camera. They appeared to be an old man and a woman, and the old man appeared to be leaning on a walking stick. The schoolmaster had no doubt that he was alone in the chapel and that he had photographed a couple of ghosts. Unfortunately, the photograph is now lost.

Eton Waterworks

Tangier Island

Tangier Island is located between the Thames and Eton College Chapel. Langston recites an incident that took place at Tangier Island in Luxmore Gardens. It would seem that the ghostly image of its creator what was captured on film in the late 1920s. The Eton housemaster who died in 1926 was passionate about gardening and created the garden in which he used to spend most of his leisure time. After his death at the age of eighty-six his friends erected a pavilion in his honour and commissioned a photograph to commemorate his forty-four years' loyal service to the college at a ceremony of dedication. A photograph was taken of the dais, on which the official group stood facing the pavilion with their backs to the camera. When it was developed the unmistakable figure of the late Mr Luxmore with flowing white hair could be seen standing amongst the guests with his stick, hunched shoulders and trademark short cape. The photograph was exhibited in the window of Kissacks Photographers at 130 High Street for many years and those who saw it had no doubt that it was the image of the well-known Eton master captured after his death.

Another classic haunting also occurred at Tangier Island, at the waterworks at the end of Tangier Lane. The local policeman would stop and share a cup of tea with the nightwatchman every night. Brian Langston summarises the events which seems to have some credibility. This haunting took place during the middle of the Second World War:

'It was the habit of the night shift workers to take a tea break at midnight when the local police sergeant would cycle down the lane to join them for a cuppa and catch up on the latest gossip.' They were accustomed through the sandbagging around the external walls to hearing 'the tick-tick-ticking of the free wheel of his bike as the policeman approached and would take this as their cue to put the kettle on. One night the workers heard the familiar sound of the approaching cycle followed as usual by sound of the sergeant's footsteps on the gravel walking towards them. They put the kettle on but were surprised when he never actually entered the mess room.

Eton Water Works, Tangier Lane, where during the Second World War a policeman who had died a couple of nights previous was heard to join the watchman for a coffee but did not appear.

The watchman mentioned this to a co-worker the following day, who informed him the policeman had died a couple of nights previous.

The Henry VI

73 Eton High Street

The Henry VI is very haunted. Langston relates that 'Vic Strangewick and his wife who ran the pub in the 1970s reported several occasions of being pushed by an unseen hand whilst working in the bar'.

The subsequent landlord, Bert Matthews, a former policeman and professional boxer, was more sceptical until he personally experienced the same phenomenon, and his wife saw the door handle in the empty upstairs quarters turn by itself. In 1979 a female customer saw the ghost of a man standing behind the landlord at a point behind the bar where an old wall had been knocked down. Customers reported having their drinks poured over them by the mischievous spirit which haunts the pub but actual sightings have been few and far between. A cleaner Mrs Metcalfe, who was

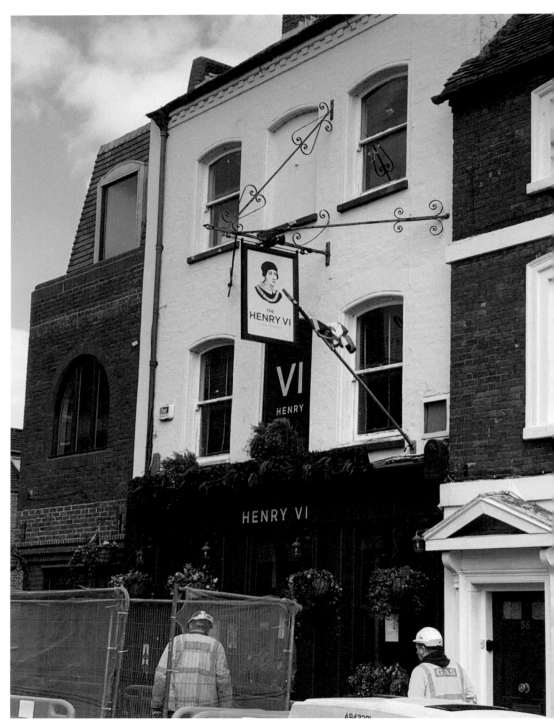

Customers reported having their drinks poured over them by the mischievous spirit.

unaware of any previous history, saw the ghost of a man in 'quite modern clothes' standing at the 'little middle bar' early one morning. As she looked towards it, the phantom figure slowly faded away.

The Crown and Cushion Pub

84–85 Eton High Street

The Crown and Cushion was built around the year 1600. Since 1753 it has been a pub which, according to Brian Langston, is known to be haunted. He gives an example involving a police constable and his crewmate who were driving down Eton High Street when 'a woman flew out through the doors of the Crown and Cushion into the road ahead of them. PC Selby stamped on the brakes and could tell straight away from her demeanour that something was seriously wrong. Fearing there was a troublemaker in the pub, the officers jumped out of the car and asked what was going on. The young woman turned out to be the barmaid and after a little coaxing, explained that she'd been changing the barrels when she had been terrified by an awful presence down in the cellar and just had to get out of the place. The bemused officers looked at each other with trepidation and tentatively asked if there was anything they could do. Much to their relief, the young woman, who had by now regained her composure, declined their offer telling them that it was always happening, and it was just something she had to put up with'!

The cellar is said to be haunted by 'an awful presence'.

The Watermans Arms

Brocas Street, Eton

The Watermans Arms lies just off the High Street close to the bridge that leads to Windsor and backs onto the Brocas Fields and the River Thames. Langston quotes an example from the mid-1980s where a new licensee of the pub reported strange activity. He said that the optics had been drained and glasses moved. Initially he believed it might be the staff indulging in nocturnal drinking, but this event was followed by the sound of clinking pint pots that were hanging over the bar and other noises coming from the walls of the pub. Previous landlords had also had interesting experiences including the sounds of groaning and sighing coming from the ancient cellar. It possibly relates to the fact that Windsor and Eton were ravished by the great plague of 1665 and the cellar of the pub had been used to store bodies of the victims that had been brought up the Thames by boat. Perhaps the sounds were spirits of plague victims. Other ghostly events have occurred at the pub including a phantom waif seen warming his hands by the fire possibly linked again, according to Langston, to the fact that in its earlier life the pub was the parish workhouse. It is also believed that the Watermans Arms plays host to two Old Etonian highwaymen. One of the bedrooms that faces across the Brocas Fields to the Thames is icy all-year round, no matter what the weather is. Using a radiator to heat the room makes no difference.

Among the many ghostly events here is a phantom child seen warming his hands by the fire.

The Prince George

77 Eton High Street

Langston reports that the 300-year-old Prince George inn is

haunted by an elderly man who has been seen sitting at a table in the corner of the bar before slowly disappearing. Mia, a new member of staff, was approached by an old lady and asked, 'have you seen my husband dearie?' When Mia jokingly asked where she had left him, the old lady replied 'oh no dearie ... He's been dead for years, but he haunts this place And I wondered whether you had seen him yet!' Mia confessed she was rather unsettled by this ghostly revelation and although she never saw the phantom figure herself, it explained why several of the bar staff complained of an uncomfortable atmosphere on occasions and did not like to be alone in the pub in the evenings. Mia became so apprehensive of an inevitable encounter with the old gent, that she left the pub not long after his wife's visit.

The ghost of an elderly man has been seen sitting at a table in the corner of the bar.

Hurley

The Priory and Ladye Place

Hurley is a quintessentially English village. Small, pretty, ancient, and located on the Thames. On the day I visited it was quiet but a lot that is of interest relating to the main hauntings is situated on private property. Hurley has a fascinating history.

The Restless Ghosts of Ladye Place by Harry Ludlam is a captivating read and gives an interesting and detailed account of the history and events that took place at Ladye Place and the ruined priory. I have summarised his account. It was a Colonel Charles Rivers-Moore who retired from the Royal Engineers in his late thirties and in 1924 purchased Ladye Place and the historic buildings which stood in the 20-acre estate. The house, the second of the same name, was scarcely a century old. The manor had originally belonged to Easgar, master of the horse to Edward the Confessor (c. 1003–5 January 1066). A church had existed on the site even then. On the Norman Conquest, the lands were given to Geoffrey de Mandeville who founded St Mary's Priory in 1086. Some of the existing buildings and most of the church dated from this time. This mansion stood for more than two centuries, falling eventually into such decay that in 1837 it was demolished, and the present house built in its place – but not on the exact site of the previous building. Colonel Rivers-Moore was keen to dig to uncover the foundations of the former priory. He believed there were archaeological treasures buried under the buildings. He was aware that a document dated the fifteenth year of Richard II mentioned that Editha, the sister of Edward the Confessor, was buried there. One of his main ambitions was to try and find her grave. He believed the ghost – the Grey Lady – that was locally claimed to haunt Ladye Place, along with the spectre of William Rufus, William II of England and son of the Conqueror, was once known to be there.

The present main residence of Ladye Place had been rebuilt round the old farmhouse of the priory, and parts of it still dated from the sixteenth century. Harry Ludlam tells us that

> between 1924 and 1930, however, being unsure of where to start, he attempted no serious excavation beyond digging a trial pit against a corner of the church, to see if the walls had once extended at that point. It was his first move in the search for Editha's grave. But three feet down he struck a flat floor or pavement of hard chalk and gave up. The strange sequence of events began in the early spring of 1930, when Mrs Rivers-Moore's brother, a doctor on the staff of a London hospital, came to stay. One day he told them he had a surprising vision in which he seemed to be in the dining room of one of the buildings in the Priory grounds known as Paradise,

Ladye Place in 2020.

Spectral monks were seen by friends and visitors to Ladye Place many dozens of times during the 1930s. The ancient Priory and Priory Church are in the background.

talking to a monk dressed in a brown habit. He remarked to the monk that it was a pity about the fireplace in the room as it was not in keeping with the house. The monk, by way of reply, said three times, 'sweep it away', making a sweeping motion with his hand – and to the doctor the fireplace then seemed to fade away, revealing behind it a circular fireplace surmounted by a big oak beam. Next day, out of curiosity Mrs Rivers-Moore asked builders who were there working in the house to remove the offending fireplace. To everyone's astonishment, when they took it out there was disclosed behind it a much older fireplace exactly as described by her brother. From this time on the ghostly incidents at Ladye Place rapidly gathered momentum. A woman visitor who stayed at Paradise had some strange experiences

in the house which, she felt sure, indicated the presence of unseen forces. She decided to take some instruction on psychic research in London, and on returning to Paradise tried experimenting with automatic writing. One day she came to the Colonel and his wife with a paper on which was written 'empty well'. As they did not know of any well about the place, however, this puzzling message meant little. Then shortly afterwards, the guest brought another scroll produced by automatic writing which seemed to be a drawing of a well at the Priory. Feeling that there might be something to this allegedly psychic phenomenon after all, Colonels Rivers-Moore and his wife, together with a few friends, decided to try a table-rapping seance in the hope of gaining information. The seance was conducted with a perfectly open mind with no medium or spiritualist present, the simple procedure being that the table should give one rap for no and two raps for yes. They found the table very quickly responsive and were soon obtaining answers from a spirit or entity who gave his name as King and said he lived 400 years ago. The sitters asked about the mysterious well, and he replied that there was such a well 13 feet south from the corner of the church and 6 feet east and that it was filled with rubbish. The Colonel, after six somewhat impatient years at Ladye Place, was willing to take a gamble, so on April 23rd, 1930 began digging where instructed; but all he found was the remains of an old flint wall. Another table-rapping seance was held and King told him that they should dig 2 feet further south. They did this, and then found a well exactly as described filled with building debris. After clearing it to some depth he struck water and work was suspended, though he had now, under guidance, uncovered the foundations of the Tudor mansion and unearthed a few relics including the foot of a skeleton. There were more table-rapping seances and Mrs Rivers-Moore, seeking a special test for King, asked 'as a spirit, can you tell me something we can find in the morning that nobody knows is there?' The answer came: 'Look for the rust line'. Next morning, they easily found the rust line just under the surface of the ground where they had been excavating, at the precise spot indicated. The message received by table-rapping continued to be so explicit that relics were unearthed within a few hours of a seance. The well and two old fireplaces and hidden foundations were discovered by these means… all that came to light that could possibly be connected with Editha was a base of hardcore surrounded by traces of tile flooring, in the centre of the north transept of the church. This may well have formed the base of some early shrine.

Ludlam continues, stating that as the Colonel dug so it seems it triggered some paranormal activity:

A woman who for a time occupied Paradise with her child became convinced there was an evil influence in the building. She was advised to sprinkle Holy Water in rooms. But just as she was about to do this, the apparition of a monk appeared to her and said, 'you must not do it – you will stop my work'. A medium was brought in, but as soon as he went into a trance the monk took possession and became violent, trying to attack the sitters. Through the medium the monk declared that he had practised black magic, and ever since he tried to keep his persecutors out of the house. He was assured by the circle that he had been forgiven by his Father Prior, whereupon he promised not to cause further difficulty in the house. Other phantoms, however, began to appear. Spectral monks were seen by friends and visitors to Ladye Place many dozens of times during the 1930s. Commonly a visitor walking in the cloisters in the early evening would see

The ancient refectory and the cloister area of the Priory, from a photograph pre-1911. In the 1930s a visitor in the early evening would see a man dressed in a monks' habit, with arms crossed, cross the cloisters.

a man dressed in monks' habit, with arms crossed, pass him and then it would vanish before his eyes. Colonel Rivers-Moore and his wife compiled a dossier of the weird happenings, their stories being signed by the witnesses. The signatures included those of an architect, a doctor, and an officer of the Navy, Army and Air Force.

The Olde Bell

High Street, Hurley, SL6 5LX

The Olde Bell was founded in 1135 as the hostelry of Hurley Priory, making it one of the oldest hotels in the world. The coaching inn expanded in the twelfth century and

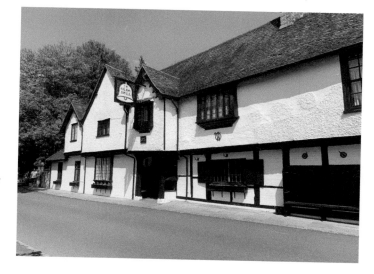

The Olde Bell was founded in 1135 as the hostelry of Hurley Priory. Ghostly chanting is sometimes heard coming from a supposed tunnel behind the fireplace which links to the priory.

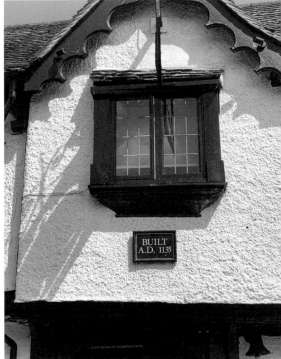

Above left: Entrance to the Olde Bell. (Image © Acabashi under Creative Commons CC-BY-SA 4.0)

Above right: The Olde Bell, founded in 1135, is one of the oldest hotels in the world.

has a secret tunnel leading to the priory, which was used by John Lovelace, who was involved in the Glorious Revolution to overthrow King James II in the seventeenth century. The hotel was also used as a meeting point for Winston Churchill and Dwight D. Eisenhower during the Second World War.

Ghostly chanting is sometimes heard coming from a supposed tunnel behind the fireplace which links to the priory.

Hungerford

Littlecote House

Hungerford, Berkshire, RG17 0SU

Littlecote House is now a Warner Holidays hotel. The original house was built in the thirteenth century, but most of what we see was built by Sir John Popham (Lord Chief Justice) who came to Littlecote in 1589 following the death of the owner, William Darrell.

I visited on a sunny summer's afternoon unsure of what to expect. The house was easily accessible and on approaching it down the drive, presented an impressive sight. I walked into the main entrance to find the hotel to be incredibly quiet. An eagerly awaited afternoon tea had to be abandoned for lack of service! The house sits in 113 acres of land and has the reputation of being the third most haunted building in England and one of the most haunted spots in Berkshire. The grounds have the remains of a Roman settlement with a stunningly preserved mosaic that is open to easy viewing. Wandering through the public rooms and through the 'haunted' areas was interesting and atmospheric. There are signs to the haunted bedroom including a notice on the door that this is indeed the haunted bedroom. I gingerly pushed the door open not knowing what to expect and found a room with an ancient fireplace, a

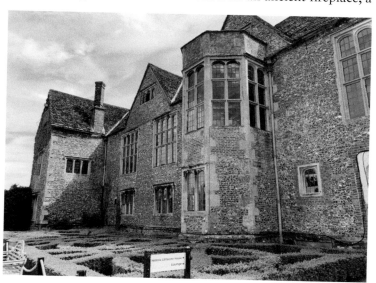

Littlecote House, now a hotel, is haunted by several phantoms.

four-poster bed and, rather surprisingly, figures in Tudor costumes near the fireplace. They represented the two key figures in the haunting that the house is most famous for – the marvellously named 'Wild Will Darrell' and midwife Mother Barnes who lived in nearby Great Shefford.

Darrell had several mistresses and lived life fast and loose. One night local midwife Mother Barnes was called for, put on a horse and ridden to Littlecote. She was blindfolded so that she would be unaware of the location where she was to deliver a baby. On arrival, she was led, still blindfolded, up a flight of stairs and into a bedchamber where her blindfold was removed. In the bed was a young woman wearing a mask to keep her features concealed. Mother Barnes could clearly see that she was in much distress and close to giving birth. In the room was a man dressed in black velvet and also wearing a mask. He told her to deliver the child. Mother Barnes was extremely uneasy, undoubtedly frightened, but she proceeded with delivering the child whilst Will Darrell looked on. Within a short time, a healthy baby boy was delivered. Mother Barnes was about to give the child to the mother when Darrell grabbed the baby and threw it into the flames in the nearby fireplace, holding it down with his booted foot. The child's cries distressed Mother Barnes and she fled the bedchamber. The child's charred remains lay in the fireplace. Darrell warned Mother Barnes not to breathe a word of what she had witnessed. She returned to the bedchamber and cut a piece of fabric from the bed hangings. She was hoping it would allow the authorities to trace the house and room from which the fabric had come. On being escorted from the house she counted the steps on the staircase for the same reason.

Mother Barnes only related what had happened, to a local magistrate, when she was close to death. Suspicion fell on 'Wild' Will Darrell, and the authorities went to Littlecote where they matched the fabric that Mother Barnes had removed. The number of steps that she had counted were also a match. Darrell was charged with murder and tried in, 1586, at Salisbury. The judge, Sir John Popham, was a family friend. It was agreed that on Darrell's death Popham would 'inherit' Littlecote. Darrell was released escaping both trial and the gallows. It is possible that the woman in the bedchamber was Darrell's sister and that she may have died after giving birth. However, Darrell had a prodigious number of relationships and the mother may have been a Miss Bonham, whose brother was in service at Longleat House. Her treatment at Littlecote by Darrell had been abusive and it was well known that she gave birth to at least one illegitimate child which sadly died. A letter discovered at Longleat House addressed to Sir John Thynme (1515–80), ancestor of the present Marquis of Bath, from Sir Henry Knyvett, an enemy of Darrell, was a condemnation of Will Darrell's behaviour. Sir Henry told Sir John of a Mr Bonham in his service, whose sister had become Darrell's mistress and about how the 'poor girl was so appalling treated at Littlecote' and 'Mr. Bonham should be urged to do something about his sister's usage.'

In 1589 Darrell fell from his horse whilst out hunting, breaking his neck and dying. It was possibly from seeing his murdered son's ghost suddenly appear in a flash of brilliant light. His ghost has been seen sat astride a black stallion riding at full gallop close to the spot where he fell, now known as 'Darrell's Stile'. It is said that he is seen wandering aimlessly about a spot 'where many horses still shy and become agitated'. He has also been seen in the bedchamber and on the landing by the fireplace where the baby was murdered. William Darrell was buried on 3 Oct 1589 at St Lawrence's

Church, Hungerford. His ghost is somewhat prolific as it haunts the wrong church – that of the Holy Cross at Ramsbury 4 miles to the north-west.

Guides and guests at Littlecote claim to have seen the ghost of a woman who appears to be weeping whilst gently rocking a baby she has cradled in her arms. In 1970, a visiting journalist took a photograph of what appears to be a woman leaning over the bed. The photograph was examined by a photographic laboratory and deemed not to have been tampered with. The terrifying screams of a baby have been heard emanating from the haunted landing and also the Long Gallery that runs adjacent to the bedchamber.

Other ghostly appearances include what is presumed to be Mother Barnes kneeling by the fireplace where the child was burned. Interestingly, Jeff Nichols in his booklet *Our Mysterious Shire* says 'Apparently, after the Second World War, Littlecote House underwent extensive alterations and repairs. Following the removal of a doorway in an old gate house, the charred remains of a baby were found bricked up in the wall, but no facts have been recorded.' A bloodstain is said to appear where Darrell threw the child into the flames. In 1922 the Popham family sold Littlecote to Sir Ernest Wills. Another intriguing incident occurred when Sir Ernest's brother, Sir Edward Wills, and his wife stayed at Littlecote. Sir Edward was woken by the sound of his Pekinese dog scratching at the bedroom door to be let out. 'What is it boy?' enquired Sir Edward. The normally obedient dog ignored him and continued to scratch at the door. Sir Edward got up, opened the bedroom door and stepped out into the Long Gallery, where he saw a woman dressed in pink whom he did not recognise walking away from him holding a lit candle. He called out to her but she didn't respond. He followed her until he lost sight of her in the direction of his brother's bedroom. The following day he related the event to both his brother and the staff and asked who this woman was. One of the housemaids stepped forward and said 'beg pardon Sirs, but I often see a lady wandering the Long Gallery wearing a pink dressing-gown, she is a happy ghost that means no harm or agitation to anyone'.

A later owner of the house was Peter de Savary, who lived at Littlecote between 1985 and 1996. During a Burberry fashion shoot in the Long Gallery, a young model was posing by the fireplace glancing out of the oriel window. A member of the film crew took a Polaroid of the model which revealed a woman in a white gown standing immediately to the model's right.

In the *Hello* magazine edition of October 1993 Peter de Savary relates that he decided to hold an auction of unwanted furniture and various other items in the house. On the morning of the sale he was walking in the Long Gallery when he was suddenly confronted by a middle-aged woman dressed in tweed. She spoke sharply, telling him he was a wicked man and no good would come of him unless he returned the box containing her baby's clothes that he had so wickedly removed from the chapel. A little stunned by this sudden outburst, de Savary was about to enquire why she was wandering about his home, when before his eyes she vanished. He was shocked but recalled the box which he had removed from a window ledge in the chapel earlier in the week. He eventually found it amongst other items for sale. On opening the box he was amazed to find it contained babies' clothes along with papers dating to 1861. He put the box back on the chapel window ledge where he had originally found it. The box and its contents are on display in the chapel.

It was in the Long Gallery that a former owner was told by a ghostly lady to return a box containing old baby clothes to the chapel or 'no good would come to him'. It is also in the Long Gallery that Sir Edward Wills saw a phantom lady wearing a pink dressing-gown and decided to follow her.

A phantom black dog has been seen on the Jerusalem staircase situated off the Long Gallery. Several years ago, a visitor was confronted by the dog as he climbed the narrow staircase. As he bent to pat the animal, he was stunned to see his hand pass straight through what appeared on first sight to be solid flesh and blood.

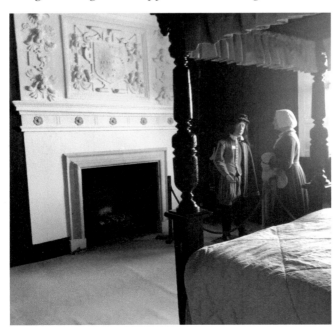

Guides and guests at Littlecote claim to have seen the ghost of a woman who appears to be weeping whilst gently rocking a baby she has cradled in her arms.

One of the more frequently seen ghosts is that of a woman standing in the garden. Some years ago, one of the guides had just finished a tour of the house and gardens and was leading her party back into the house when she noticed a woman standing in the garden looking at the house. Thinking she must be one of her party, the guide called out to her to join them, and at that moment the mysterious woman disappeared. She bears a striking resemblance to Mrs Leybourne-Popham whose portrait hangs in the Regency Room.

During a séance in this room a woman was seen rocking a baby in a corner and dark shapes were seen moving around the room. Individuals in the room also felt extremely cold, although no drop in temperature was recorded on their equipment.

In 1970, a visiting journalist took a photograph of a phantom woman leaning over the bed.

Left: The terrifying screams of a baby have been heard emanating from the haunted landing which adjoins the 'haunted bedroom' and the chapel.

Below: A ghostly woman told owner Peter de Savary that he was a wicked man and no good would come of him unless he returned the box containing her baby's clothes that he had so wickedly removed from the chapel.

The box in the chapel that contained the deceased baby's clothes.

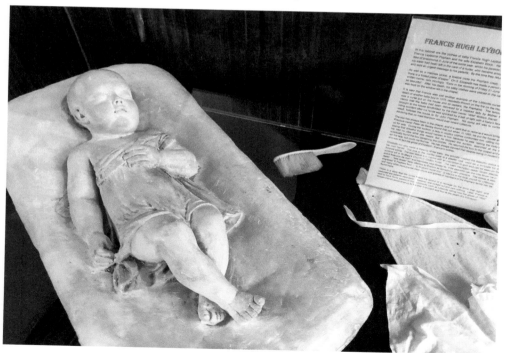

The baby whose figure stands in the glass case in the chapel is that of Francis Hugh Leyborne Popham, another victim of the Littlecote curse, which decreed that no male first-born would ever inherit Littlecote. He died in 1861 of pneumonia at the age of five months.

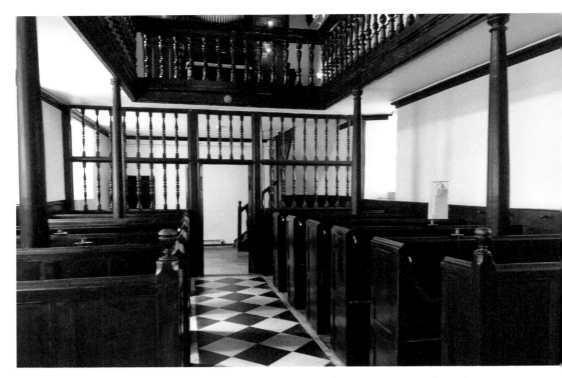

The chapel is said to have a disembodied arm that has been seen moving along the pews.

Littlewick Green

Littlewick Green is an ancient, quiet secluded village which has developed around a large village green. It reputedly plays host to three phantoms, although on the day I visited nothing was seen. The white 'Dog of Feens', which is apparently black, appears between the woods by Chalkpit Farm and the entrance to Feens Farm on the Bath Road. It is conjectured to be a Roman hunting dog which howls to warn people of the approach of the ghost of Dorcas Noble. Dorcas Noble was a local woman from a reputable family who was betrothed to a gentleman from Billingbear Park. However, when a rival appeared on the scene, she unsuccessfully resorted to witchcraft in order to win him back. Soon afterward, she was murdered in Green Lane, her head being practically severed from her body. Her spirit leads a spectral wild hunt around Windsor Forest – a headless young woman in grey apparel. The third apparition is a white lady who is said to haunt a set route from Boundary Elm, down Green Lane and through the Green to Cold Harbour and Knowl Hill. In a house in Green Lane, she walks right through the sitting room. From reports of her clothing, when seen at Green Lane, she may have been a Vestal Virgin from the Roman Temple on Weycock Hill in Waltham St Lawrence. There is yet another reported haunting – that of a small child called Nellie who appeared in one of the houses on the Green, and was eventually exorcized.

Littlewick Green. A small child called Nellie appeared in one of the houses on the Green.

Newbury

Newbury

A34 Bypass near Wash Common

The Battlefield Trust, which is deeply concerned about modern encroachment on historic battlefield sites, believes that the Newbury Bypass was 'constructed from north to south across the site of the First Battle of Newbury ... probably largely to the rear of the Parliamentarian positions'. This important English Civil War battle took place in 1643, and it is believed that the building of the A34 disturbed the mass graves of both Royalist and Parliamentarian soldiers who were killed. Whether this is the case or not, as a matter of interest David Appleby, in a recent book[6] commenting on battlefield mass burial sites observes that 'any lump or bump on a battlefield has generally become, in popular memory the site of a mass grave'. He says that 'mounds upon Wash Common at Newbury, were by the late nineteenth century, remembered as marking the site of mass graves from the first battle of Newbury'. The presence on the Newbury Bypass is said to be ghostly figures floating along the road. The Paranormal Database for Berkshire gives the last sighting as being in October 1996 and 'manifesting as shadowy figures that vanished when approached'.

There are a couple of interesting posts on the 'Haunted Island' website relating to the same area. One posted by Tanya Patrick in 2015 reads as follows:

> My grandparents lived in Cromwell Road until recently when the house was sold due to my grandad's death, and they had the house from brand new after the war. My mother and father were courting and sleeping in the back lounge when they both saw an old lady in old fashioned clothing walk through the wall. She had a mop cap on, and feet were below floor level. The house had a lot of issues with ghostly goings on. Too many to mention here.
>
> My uncle who grew up in Cromwell Road lives now in Kingsley Close has done for a long time. I also am aware that people hear the old train on this estate that went to Didcot, even though it no longer runs, and some local families have reported 'issues' of the non-humankind in various houses. I have dug around in old newspapers and nothing can account for an old lady in written records. I also lived in Love Lane for a couple of years opposite the battle ground ... and we did here noises and experience strange things there too.

6. Battle-scarred: Mortality, medical care and military welfare in the British Civil Wars

Another comment on the website comes from Mike Carpenter writing in 2012:

> About 36 years ago while I was staying with my future wife at her parent's home on Kingsley Close in Newbury, I awoke one night freezing cold, shivering … it was August at the time. I noticed across the lounge, an elderly woman walking to the kitchen. I got up to help her because I thought it was my future wife's Grandmother. As I got close, I could see she had on very old looking clothing. When I was about 8 feet away from her … she vanished! My in-laws home was built near old Roman ruins … we would find bits and bobs when the farmer would plough his fields behind the home. I still think about this to this day.
> (http://www.hauntedisland.co.uk/ghostly-battlefields/newbury-bypass-berkshire)

The Market Place in Newbury was the site of the old pillory. In 1538, Thomas Barrie, a resident of the Donnington Almshouses, was believed to be spreading seditious rumours about Henry VIII and consequently had his ears nailed to the pillory and chopped clean off. He died of fright and his ghost has been seen wandering about the spot ever since, moaning in agony.

The 'Berkshire History' website mentions an early theatre built in Pelican Lane in 1802. One of the actors fell deeply in love with his leading lady, but she spurned his

Market Place in 2020. The area where the Guildhall, now long demolished, stood is said to be haunted by the ghost of Thomas Barrie who died of fright in the stocks in 1538.

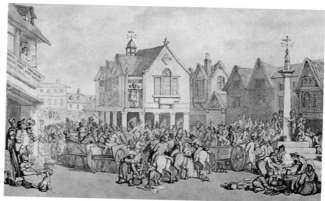

Market Place in the eighteenth century showing the stocks on the first floor of the Guildhall.

advances in favour of another. In a fit of jealous rage, he stabbed her to death one evening after the curtain had fallen on their latest performance. Years later, the theatre became a private house. Residents reported their candle being suddenly blown out while ascending the stairs at night, then mysteriously relighting. When electricity was installed, the bulbs appeared to blow at the same spot, but were later found to be perfectly good. One couple even witnessed a ghostly bloodstain appear in the room below where the actress had been killed – yet in the morning it was gone. The building has since been demolished.

At No. 73 Northbrook Street, in the rooms above what used to be Bateman's the Opticians, across the alleyway from the Oxfam shop, is said to be the ghost of a Dr Watson who lived there and had his surgery there. He appears on now demolished stairs as an old gentleman, dressed in a black cape and top hat, carrying a black bag and silver-topped cane. He only appears from the knees upwards, as the floors have been raised. He has also been seen walking silently in the street outside, while a non-existent piano is also sometimes heard from an upstairs room in the building.

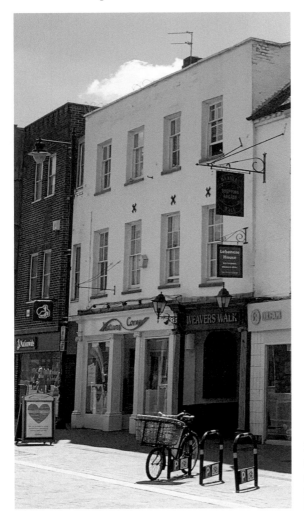

No.73 in 2020. The white building on the left is haunted by an old gentleman dressed in a black cape and top hat. He also appears outside the building in the street.

Waterside Youth & Community Centre

Waldegrave Place, Northbrook Street, RG14 1DS

The youth centre was built on the site of an old nonconformist chapel and its graveyard. The builders were exposed to a number of bizarre goings-on, including large amounts of steel being neatly moved overnight and ghostly taps on the shoulder. A previous centre had experienced similar poltergeist activity involving pots and pans and mysterious footsteps. The original chapel had been demolished because tormented souls wailed in the graveyard and the congregation deserted the place. It was at the spot that a so-called witch was dragged from the Kennet after having been murdered by Parliamentary forces during the Civil War!

What used to be the Vyne Inn, on the Black Boys Bridge, is haunted by the ghost of a stocky old man wearing a white frilly shirt and brown jerkin. He is believed to have been a long-dead ostler who worked at the tavern.

The ghost of a Quaker lady is sometimes seen in Cheap Street in the late evening. The old Quaker burial ground was on the site of the bus station.[7]

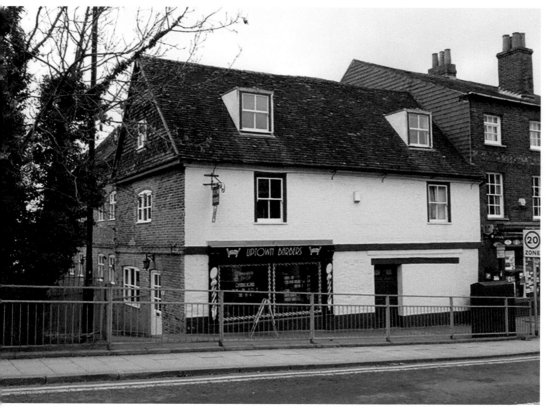

A long-dead ostler haunts this building. He worked here when in it was the Vyne Inn.

7. http://www.berkshirehistory.com/legends/ghosts_n.html

Sonning

In 1396, the seven-year-old daughter of King Charles VI of France, Princess Isabella, married King Richard II of England. After his deposition in 1399, she was held prisoner at Sonning Bishop's Palace in the charge of Richard Metford, Bishop of Salisbury, until 1400. Her ghost still haunts the lower regions of Holme Park where the palace stood and also the towpath beside the Thames where she once took her daily walk.

Sonning Mill, mentioned in the Domesday Book, supplied flour locally for nearly a thousand years until 1969. It was later converted into a brand-new Dinner Theatre, one of the first of its kind in the country. It is haunted by the ghost of a Lady Philomere who drowned herself in the water by the mill.

Another phantom that is said to haunt the Thames at Sonning is that of Isabella of Valois. In 1399, following Richard II's overthrow and imprisonment by his cousin, Henry Bolingbroke, the King's child bride was temporarily imprisoned in the Bishop of Salisbury's Sonning residence. The residence is long gone but stood in what are now the grounds of Holme Park, just over a mile from the mill at Sonning. Isabella returned to France, so it is perhaps doubtful that she is still haunting at Sonning.

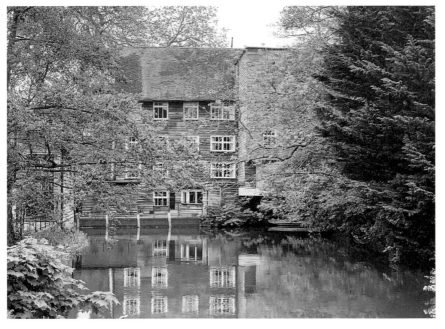

Lady Philomere committed suicide by drowning herself here and haunts the site. My research as to who she was and why she committed suicide has come up with very little.

The ghost of a Miss Rich leaps over the high, irregular fence in Sonning Lane to gaze at her old home, Holme Park. She is seen to emerge from the shady lane and disappear over the railing, rising gradually and sinking slowly, dressed in the costume of the middle of the nineteenth century. Lady Philomere is said to have thrown herself into the nearby waters to end her life, and now haunts the theatre.

Above: The ghost of a little girl has been seen crossing Sonning Bridge.

Right: The ghost of a little girl and the ghost of a white hare have been seen on the bridge. The ancient bridge, which was completed in 1775, replaced an earlier wooden one.

Laura Holland in the *Daily Express* in January 2015 commented on the haunted nature of one of Sonning's best-known residents. 'But now it has emerged that the A-List star's £10 million property comes with a spooky addition – in the form of a child ghost. The actor's nine-bedroom house on the River Thames in Sonning is the perfect place to see the ghost of a little girl who roams the village. That is according to one of Sonning's other celebrity residents, spoon bender and paranormal "expert" Uri Geller. Geller, [then] 68, says the Berkshire village is the site of some unusual activity, particularly near its historic bridge. There is a ghost of a little girl who crosses [the bridge]. "You can see his house from Sonning Bridge, and I have seen strange things happening on that bridge," Geller said. "There is a ghost of a little girl who crosses it. I have no doubt in my mind that George Clooney will see her. It is the best house in the neighbourhood to be able to see this ghost." In 2013 Geller claimed the child ghost was responsible for putting up a post-box which mysteriously appeared in the middle of Sonning Bridge. Another ghost associated with the bridge is that of white hare. Supposedly this was said to be the spirit of the corn and was unlucky if seen'.

Tidmarsh

River Pang

Mill Lane, Tidmarsh, Reading, Berkshire, RG8 8ER

Near the old rectory in Mill Lane, Tidmarsh, the spirit of a young boy has supposedly been spotted rising out of the River Pang at night on several occasions. Witnesses say the boy's face is distorted and bloated from the river water and his clothes are shredded, but according to reports he never makes a sound. He is said to have slipped and drowned in the river years ago. The last appearance is said to date from the 1880s.

A phantom young boy has supposedly been spotted rising out of the misty River Pang at night.

Wargrave

The Bull Inn

High Street, Wargrave, RG10 8DE

The Bull at Wargrave is well worth a visit for the atmosphere, friendly staff and excellent food. On the day of my visit I discussed the existence of the reported spirits with some members of staff including a charming young lady responsible for cleaning the rooms, including the reputedly haunted Room 2. As I looked around the room,

In the 1820s, the landlord's wife, thrown out for having an affair, died of a broken heart and returns every year on the anniversary of her ejection, sobbing as she packs her bags.

I asked her if she had ever seen anything unusual. 'Not in this room', she replied, 'but in the hallway outside the room I have sometimes felt a strange presence, but I've never actually seen anything'. The main haunting story for The Bull is that for nine years it was the home of the Gibbs family. Almost every year, at about the time of the Henley Regatta, they would hear crying coming from Room 2 at night. The reason is likely to be that in the 1820s, a former landlord had discovered that his wife was having an affair. He immediately threw her out on the street, forbidding her to return

Above: A visitor sitting near the fire claimed to see the figure of what he believed to be a burning baby in the flames.

Right: The haunted Room 2 at The Bull where a lady is heard sobbing.

Gaunt Cottage in Church Road is reputedly built on the site of a Saxon palace where the ghost of a Saxon queen has been observed walking into the adjoining building.

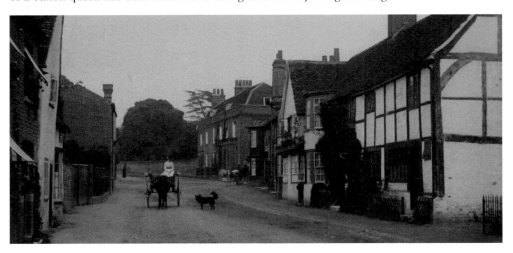

Church Street, looking eastwards, *c.* 1888. On the south side are Wargrave House, Little Gaunt and Gaunt Cottage. 1880–89 glass negative by H. W. Taunt.

or see her young child. She died of a broken heart soon afterward, and her spirit returns every year on the anniversary of her ejection, sobbing as she packs her bags.

A short distance, maybe a hundred yards, from The Bull in Church Street is Gaunt Cottage which is said to be haunted by a 'lady in white'. The lady walks through the wall to the adjoining cottage. It is speculated that she may be the Saxon Queen Emma who, it is said, had a palace on the site.

Barrymore

6 High Street, Wargrave

The 7th Earl of Barrymore (1769–94) was a notorious gambler, brawler, philanderer, practical joker and theatre devotee. He ran up large debts from his free and easy lifestyle.

Richard Barry was known as 'Hellgate' by the Prince Regent, which was a reference to his debauched lifestyle and ultimate destination. He rented a house in Wargrave and with his passion for the theatre he borrowed an advance against his inheritance which he would receive when aged twenty-one and built a theatre opposite the house in the High Street to indulge his passion. Barrymore was a prolific gambler, lover of horse racing, boxing and bare fist fighting – both watching and participating. He held wild parties with the debauched Prince Regent. During his relatively short life he had numerous liaisons with numerous women, including a Miss Ponsonby who had a connection to the Dukes of Devonshire, but her father put a stop to this as Barrymore was not considered to be a suitable match for his daughter. He then had a brief but intense relationship with a Mary Ann Pearce who lived with him at Barrymore. That relationship came to an end in 1792, when Lord Barrymore, aged twenty-two, ran off to Gretna Green and married the daughter of a London sedan chairman. The fast lifestyle ended abruptly when he was sent to escort some French prisoners of war at Dover. It all came to an end at the time of the French Revolution when his regiment was sent to help strengthen the coastal defences at Folkestone. He was placed in charge of sixteen French prisoners, so was obliged to keep his rifle constantly loaded. Later, they stopped at an inn for refreshment and the earl enjoyed the interlude in his usual fun-loving manner. A book of his life written in the year of his death describes the earl's gruesome demise:

he was with his regiment, the Berkshire Militia, at Rye, when a party of French prisoners, to the number of 16, were ordered to be escorted to Deal. Barrymore with a party of 20 soldiers 'marched through Folkestone to the top of the adjoining hill. He halted at a small public house, to refresh his own men and the prisoners with beer, and bread and cheese; here Admiral McBride and General Smith met his lordship, and entered into conversation with him; he was in high spirits, and I believe, promised to meet them at dinner either at Deal or Dover. Lord Barrymore, who had hitherto marched at the head of the party on foot, informed his *valet to chambre*, who drove his *curricle* (small horse drawn coach) in the rear, that he would procure a pipe of tobacco at the ale house, and ride and smoke, while his servant drove: - while he remained in this house, he was extremely pleasant with the landlady, took a piece of chalk from the bar, and insisted upon marking the amount of the bill upon a slate, which hung behind the door ... he drank a glass of brandy with his hostess, kissed her, leapt into his carriage, and gave his *fusee* (musket) to this fellow, who placed it awkwardly between his legs, they had not proceeded above 50 yards down the hill, when the piece suddenly went off, and the contents entered the right cheek of his Lordship, forced out the right eye, and lodged in his brain; the left arm of the man in his coat was burnt with the powder; - he was martyred in the act of pointing with his pipe, to show his servant how plain the coast of France appeared in view... From the moment of this disastrous event took place to his expiring, which was a period

of 40 minutes, he never articulated a word, but groaned incessantly, till his sensation seized in death.

His piece was charged with swan shot, with which he had been furnished by the turnpike man – and he had been previously amusing himself with killing the gulls and rabbits, as he marched along! - there were a few drops of blood on the lining of his regimental cap, which fell off his head as his body sunk up on the left side of the curricle, when the brains oozed upon the wheel through the lacerations in his cheek, until his coachman, who rode behind the carriage, equally removed his masters head, and replaced his right eye in the socket. He was conveyed to the public house he had recently acquitted … and a surgeon was brought from Folkestone … Alas! both skill and attention were equally fruitless; his pulse gradually slackened and his extremities

Barrymore, left, with his two brothers in a not very complimentary contemporary cartoon, 'The three Apes'.

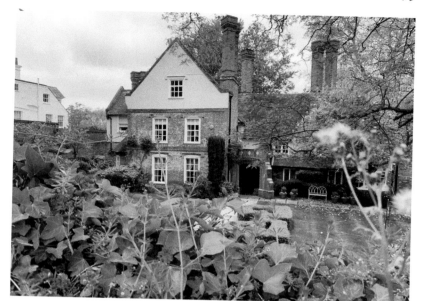

The Earl of Barrymore and a lady in grey haunt his former home in Wargrave High Street.

Barrymore is buried in the chancel of the Wargrave parish church.

stiffened: this was the scene of horror, both to his own company and their prisoners, who all shed tears abundantly over the yet warm body of their common friend.[8]

At Barrymore House his spirit is said to hide door keys and attempt to push visitors down the stairs. A lady in a grey silk dress also haunts the house and the swooshing of her skirts is heard as she materialises. The smell of lavender accompanies her. It is said that dogs will not go upstairs in the house. The house is a private residence.

8. The life of the late earl of Barrymore, by Anthony Pasquin, Volume 3 1793

George & Dragon

Wargrave

A short walk from the Bull alongside the Thames is the George & Dragon, which was once the site of a Thames ferry. In the winter of 1878, the Thames froze over and this became a popular spot for skating. A Captain Markham insisted that the ferryman take him and his sister across the river so they could join in. Reluctantly he agreed and, helped by his young daughter, he undertook the trip. However, disaster struck and the ferry sank. The adults just managed to make it to the banks, but the little girl was drowned. Her spirit was later seen walking along the riverside path behind the old inn.

The ghost of a little girl who was drowned in 1878 has been seen walking along the riverside path behind the St George and the Dragon Inn.

Windsor

The Windsor Werewolf

This image is of a wolf photographed by photographer JP Valery in the French Alps. It resembles the descriptions given in both Windsor and Maidenhead sightings.

Moving slightly away from the realm of phantoms and poltergeists, Brian Langston devotes a short but fascinating chapter to what he calls the 'Windsor Werewolf':

On the day I visited both the sites mentioned in his report – admittedly during daylight – I felt uncertain as to what it was that had been seen. He says that in November 2000, 'two Windsor police officers had a nocturnal encounter with a strange wolf-like creature seen at the edge at the Thames near to the Windsor Canoe Club. PCs Tom Walters and Lucy Palmer were on a routine patrol during the early hours of the morning and could not believe their eyes when they caught the looming

A wolf photographed by photographer JP Valery in the French Alps. It resembles the descriptions given in both Windsor and Maidenhead sightings.

figure of an enormous wolf-like beast in their headlights in the Windsor Leisure Pool car park in Stovell Road. Startled by their sudden arrival, the beast turned and loped away towards the river disappearing into the shadows, leaving the bewildered officers wondering what they had just seen. Lucy said 'It looked too big to be a dog and seemed irritated that we had disturbed it. It had an odd gait and walked towards the river where it vanished. Tom and I were dumb-struck and just looked at each other as if to say what the hell was that? There was no way either of us was getting out to check. It looked for all the world like a big wolf, so we made a note of it just in case but no-one else ever reported anything'.

In fact, unbeknown to the officers, an identical beast had been spotted by one of their colleagues a decade previously, 6 miles further along the Thames at Boulter's Lock in Maidenhead.

Langston, himself a retired high-ranking Berkshire police officer, continues the narrative which provides a chilling description of the creature spotted in Maidenhead:

One cold and damp night in February 1990, PC Gail Emptage was coming to the end of her late-night anti-burglary cycle patrol and decided to do a final tour along the river. She cycled along Ray Mead Road from Maidenhead Bridge towards Cookham.

Two police constables could not believe their eyes when they saw the figure of an enormous wolf-like beast in their headlights in the Windsor Leisure Pool car park in Stovell Road.

The strange wolf-like creature was seen at the edge of the Thames, near to the Windsor Canoe Club on the right.

It was half-past midnight and as silent as the grave with not a soul in sight as the mist blew across her path from the river. As she passed Boulters Lock she was startled by a sudden movement coming from the direction of the Thames towpath.

Gail recalled: 'I had just cycled past Boulters Lock when I heard something move on the riverbank. I saw what I thought was a large shaggy dog. It was so big that my first thought was that it must be a St Bernard. As it loped across the road just 20 feet ahead of me, it was clearly illuminated by the street lighting and I could see it had the appearance of a huge wolf. It had a thick shaggy coat which was dark grey in colour. The texture of its coat was matted not unlike the fleece of a "Herdwick" Sheep. There was no doubt in my mind that it was solid and real.'

The creature walked across her path into the mouth of the junction with Lock Avenue opposite, and then suddenly stopped. Its ears pricked up almost as if it had just sensed her presence. Gail stopped her bike in the middle of the road and froze as the beast slowly turned its head in her direction and stared at her over its shoulder.

Gail continued: 'My blood ran cold … it had an air of arrogance and almost human intelligence. It had canine features with a long muzzle and upright pointed ears but what terrified me most were its eyes. They glowed with an intense yellow-green luminosity and fixed their glare on me for several seconds. They were like two torch beams – nothing like any dog I have ever seen. It was almost daring me to approach.

In February 1990, PC Gail Emptage reported seeing a strange creature that had the appearance of a huge wolf.

> 'I don't mind admitting I was terrified. I turned my bike round and pedalled as fast as my legs could carry me back to the police station. I never went down that stretch of road again alone after dark.'

Langston makes the point that there are similarities between the two incidents and that there have been for centuries, within the Berkshire boundaries, sightings of strange wolf-like creatures. Fascinated by these reports I looked on the Berkshire Paranormal Database and discovered two further unusual sightings.[9] One was at Curridge in the passageway behind the Women's Institute Hall in October 2012. 'A sixty-centimetre-tall, long necked creature was seen by Don Prater as he walked his dog. He described the creature as being dark or grey in colour, having a head like a deer, a neck similar to a swan and a bushy tail. The picture he sketched of the creature resembled an alpaca, although all local alpacas were accounted for.'

The other sighting was described as a 'shadowy creature' in the general area of Bagley Wood in May 2015. 'Walking through the woods after dusk, a couple found

9. https://www.paranormaldatabase.com/berkshire/berkdata.php

themselves chased by a large shadowy quadruped that stood just over a metre tall. One of the witnesses said it did not move like a deer or a dog.'

The Windsor Martyrs

The Windsor Martyrs were English Protestants executed at Windsor in 1543. Their names were Robert Testwood, Anthony Pierson and Henry Filmer.

In 1543, at a time when to be a Catholic was tantamount to treason, the three were arrested and condemned on 26 July. It said that all night long, the prisoners called on God for his aid and strength, and prayed for the forgiveness of their persecutors, until sleep finally overtook them. Their guards, and even the sheriff, was quite moved by their words. On 4 August, the small party was conducted from their prison,

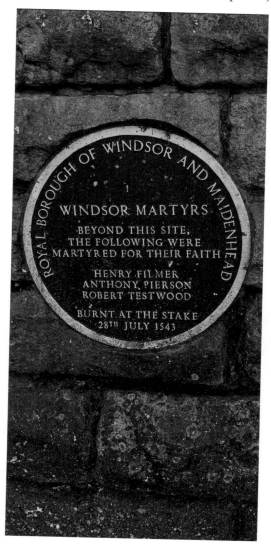

The plaque reads that it was 'beyond this site that the following were martyred for their faith'.

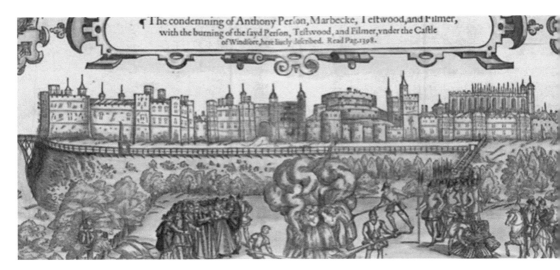

A contemporary illustration of the trial, procession and burning with Windsor Castle in the background.

In the immediate background is the location of the plaque, and the executions took place in the distant background left where Windsor & Eton Riverside railway station now stands. The area where the plaque is located is said to be haunted by a figure in a dark monk's cowl and habit.

through the town, to a field below the castle walls, on the site of the Windsor & Eton Riverside railway station. Having expressed, at the stake, their utmost confidence in their passage to Heaven, the three meekly yielded to their fate amongst the flames.[10] On hearing of the execution Henry VIII exclaimed, 'Alas! Poor innocents!' Amongst those watching in the crowd was the vicar of Bray. So shocked was he by the spectacle that he swore to himself he would keep his head down so he might always remain 'the Vicar of Bray still'.

The area in front of the memorial is said to be haunted by a hooded monk-like figure.

Windsor Castle

As would be expected, Windsor Castle lays claim to several ghosts. In his book *Haunted Berkshire*, MacNaghten tells us of a number of them. Two elderly ladies told him a story which had been passed down from an earlier generation, so the incident may have happened in the nineteenth century. One evening, a guardsman on duty on the East Terrace saw an extraordinary creature which he described as being like an elephant. He was so frightened that he shot at it. The bullet passed through the animal, chipping the castle wall. The creature vanished. This must have taken quite some explaining. The same ladies spoke of the ghost of a little woman in a brown dress who appeared where part of the royal archives were stored, but she was looked upon as a friend.

MacNaghten says that he knew of only one first-hand account of a ghost in Windsor Castle. This was from a man who as a boy lived in one of the houses in the Horseshoe Cloisters. One day he was washing his hands at the kitchen sink when suddenly he saw a man leading a horse across the room which vanished into the wall beyond. The maid-of-all work, who was also in the kitchen, saw this too, but neither of them was believed by the rest of the family. Sometime later, however, when repairs were being undertaken in the kitchen, a large underground stable was found behind the wall into which the horse and groom had disappeared.

Several other houses in the Horseshoe Cloisters appear to be haunted. In one, occupied at that time by the head chorister and his family, the ghost of a woman in white used to appear every evening at six o'clock. The family looked on her as a friend. MacNaghten relates an account that he classes 'as well authenticated as any records of the incidents' related to a Lieutenant Glyn who was sitting in the Windsor Castle library reading. It seems he became aware of someone passing into the library. He looked up and saw a female figure in black with black lace on her head that fell onto her shoulders. He was sitting in a chair on the east side of the first room, from which a few steps lead up into a gallery built by Elizabeth I. After traversing it the figure turned sharply to the right and disappeared where, in former times, the Queen used to descend by staircase to the terrace. It was four o'clock on a February afternoon, just before closing time. When the attendant came to close the door Lieutenant Glyn asked who the lady was who was at work in the inner room. 'No one', said the attendant. Glyn replied, 'I have just seen her now walk into the inner room.' The attendant went to see, found no one and returned. 'She must have gone

10. http://www.berkshirehistory.com/articles/windsor_martyrs.html

out of the door in that corner,' said Glyn pointing to where, in past times, the gallery staircase ran down to the terrace. 'But there is no door there,' said the attendant, greatly marvelling at the sudden disappearance of the lady in black. The Lieutenant departed. When the attendant reported the occurrence to the librarian, Dr Holmes, he at once sent for Lieutenant Glyn for a description of the figure. The librarian told him 'you have seen the apparition of Queen Elizabeth'. The Empress Frederick when a child is said to have seen the apparition in the same place. This account was published in 1897.

Another well-attested haunting involves George III. The king's gloomy rooms overlooked the North Terrace, and in his saner moments on hearing the approach of the guard, the king would stand at the window to see them pass below and would raise his right hand in acknowledgement of the guard commander's 'eyes right' command. The king died there on 29 January 1820, and his body, in its coffin, lay in state in another part of the castle whilst preparations went ahead for the funeral. The guard routine continued, and the command 'eyes right' given as they passed the late king's rooms. As the guard commander looked up he saw the dead king raise his hand in acknowledgement.

An overnight visitor to the castle was reported in the local newspaper:

one evening in 1873 I was visiting some friends who then resided in Windsor Castle. It was a calm still night and there was no moon. I passed down the broad roadway leading to Castle Hill. My attention was arrested where now is the site of Saint George's Chapel by a magnificent group of statuary in black. It stood on the left side as I walked down the roadway to go out. The figures presented were three bending and the crouching form of a fourth. The centre figure had in his hand a large sword, which was as if in the act of striking. The figures interested me greatly, but I had never seen them before, although I was well acquainted with the castle. The thought that occurred to me was that it was not there that morning and it surely could not have been put up in so few hours. I stood looking at the group for some minutes. Going out the entrance I spoke to the sentry there, told him what I had seen and asked him if he knew anything about it. He came as far as the end of his beat and said he could go no further, so I went a few yards on before him, to point out where I had seen it. When I got to the spot, it had gone. I went home and have often wondered what it was I saw, or what it was I was caused to see, but I have never been able to discover.

The Curfew Tower was built in 1319. In 1536, a local priest was accused of supporting the Pilgrimage of Grace and was hanged from a tree near Windsor Bridge. He implicated a local butcher who then suffered the same fate at the castle gate, although local tradition suggests that the butcher, Mark Fytton, was actually hanged for selling poisoned meat which caused the death of many local people. Their bodies were then displayed from the gibbet at the top of the Curfew Tower until they rotted. Recently officers from the Royalty Protection team, responsible for securing the rooftops during state events, confirmed that the hook from which the corpses were suspended still exists at the top of the tower.

The Curfew Tower has many ghostly phenomena associated with it. The sounds of phantom footsteps have often been heard on the stone steps leading up to the top of

Ghostly footsteps are heard on the staircase in the Curfew Tower and on one occasion the bells began to swing on their own while the temperature became distinctly chilly.

Mark Fytton, a butcher, hanging from the Curfew Tower.

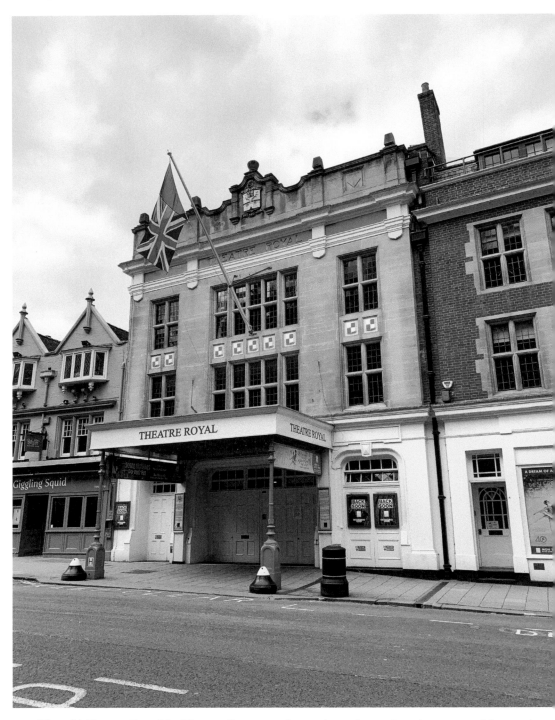

The old Theatre Royal in Thames Street was burnt down in 1908 and a young girl named Charlotte died in the blaze. Her ghost, and several more, now haunt the present theatre rebuilt on the same site.

the tower and on one occasion an observer reported that the temperature suddenly plummeted and the bells began to swing inexplicably of their own accord.

The Mary Tudor Tower is haunted by a ghost described as a woman in a grey dress and a white cap. It was seen by Princess Alice, the Countess of Athlone, the last surviving grandchild of Queen Victoria.

The Theatre Royal in Thames Street lays claim to several ghosts. Langston reports that in January 2001 during a pantomime production starring John Challis and the late Eric Sykes, the company was startled by cupboard doors flying open of their own accord and pearls being mysteriously scattered across the floor, as if being thrown by an unseen hand. This type of poltergeist has been witnessed in this building for over 100 years.

The original building dated from 1823 but was destroyed by fire in 1908. A nine-year-old girl named Charlotte died in the blaze and her ghost now haunts the theatre that has been rebuilt on the site. A young boy aged around seven is seen with Charlotte playing hide and seek. In 2014 the Berkshire Paranormal Group conducted an assessment in the building. They encountered what Langston calls a rich seam of paranormal activity. The ghost of a well-bred but impatient lady dressed in Victorian clothes is believed to haunt the fourth row of the upper circle. Another ghost is said to haunt changing room number 3 where an ice-cold chill and the smell of fresh flowers is said to be experienced. The same room is home to a phantom actress who was murdered there following a blow on the head from a deranged fan. Langston reports that the duty manager was doing his rounds and carefully locked and closed all the internal doors. After finishing his rounds, he returned a short time later and found that the doors had actually burst open. He fled in terror. In one part of the lobby pipe smoke can be frequently smelt.

Sir Christopher Wren Hotel

Thames Street, SL4 1P

The hotel sits on the approach to Eton Bridge but there is no evidence that it had any connection with Wren. There are a number of events associated with the building. It has had the reputation as a haunted house for centuries. During the nineteenth century it was the home of the Cheshire family. A daughter had an illegitimate child and was confined to her room, which was at the back of the house. The child subsequently died. Bad luck struck the family both financially and health-wise and a number of owners subsequent to the Cheshires reported seeing the ghost of a young woman in the walled garden. Langston tells us that in the latter part of the nineteenth century the house was taken by Baroness de Vaux:

Her son was much amused by a ghost in one of the smaller bedrooms at the back staircase, which is believed to be the one where Miss Cheshire had been confined. His mother refused to sleep in their room because of its eerie atmosphere. She found it impossible to retain staff at the house, and servants left in droves claiming to have seen ghostly figures. Around 1918 the house was left empty for some years and its derelict and foreboding appearance, together with its false windows, led it to acquire the ominous local nickname of 'the haunted house'. Many people were so

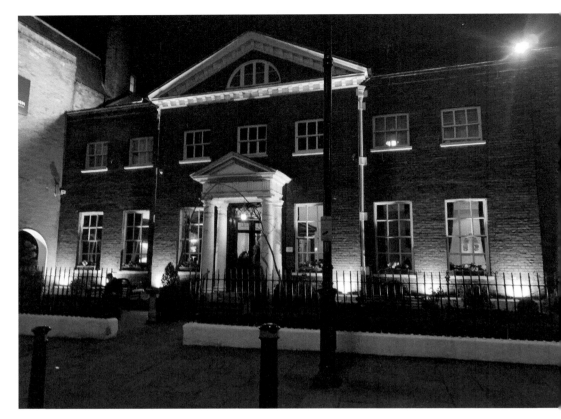

The Sir Christopher Wren Hotel on the Windsor side of the bridge to Eton has several ghosts including a ghostly face peering out from the windows.

intimidated by it that they took a detour rather than walk past it for fear of seeing a ghostly face peering out at them from the grimy windows. However, in the 1920s two sisters, bought the house convinced it was haunted, and ran it successfully for many years as the Riverholme Restaurant and Guest House.

Langston relates a further haunting that took place in the 1970s when some guests, a husband and wife, returned late, went to bed and fell asleep. The wife

awoke a little time later to find a man standing in the darkened room next to a chest of drawers. At first, she thought it was her husband but then noticed he was asleep beside her. She then feared it might be an intruder and so kept very still to avoid possible attack and continued to watch him, intending to raise the alarm when he left the room. The figure loomed silently towards the bed and approached the closed bathroom door. When it reached the door it vanished.

The servants of the owner, Baroness de Vaux, refused to stay in the building and local substitutes had to be sought instead. The ghost is particularly associated with one of the smaller guest rooms up the back staircase. One witness described it as a tall figure of a man, but with no associated menace.

Windsor Great Park

Herne the Hunter, who is more often seen in the Great Park, became the favourite huntsman of King Richard II when he saved the monarch from being mauled to death by a cornered stag. Being wounded in the process, he was later healed through witchcraft and the wearing of the stag's antlers. Unfortunately, though, his subsequent friendship with the king and skill in the field bred jealousy in his colleagues and he was framed for theft. Shame led him to hang himself on 'Herne's Oak', in the Home Park. His spirit has since been seen many times careering across the Great Park.

The Long Walk is haunted by the ghost of a young Grenadier guard who shot himself while on duty there in the 1920s. He was seen by at least two of his colleagues, immediately after his death.

Park Street

Park Street leads into the Long Walk and has several hauntings.

Angus Macnaghten reports there seems no rational explanation for a story about Park Street which has all the hallmarks of a traditional haunting. Leading off Park Street is a passageway known as Black Horse Yard, the only reminder of an old inn

Gate House, the first house on the left next to the entrance to The Long Walk, is where strange noises were heard in the cellar.

Park Street, which has a number of ghosts, leads to the entrance to The Long Walk, which is haunted.

of that name which used to be there. Many of the eighteenth-century houses in the street have now been turned into offices and this applies to Gate House, near Black Horse Yard. For many years the house belonged to a Miss Smith, who lived there with her aunt, and the family were firm believers in the story that the house was haunted but that manifestations only occurred just before the death of the reigning sovereign. According to tradition the haunting was that of a coach leaving Black Horse Yard and conveying one of the royal physicians to the bedside of Charles II as he lay dying. Macnaghten heard the story from a niece of Miss Smith and she wrote it down for him. 'Just before the death of Edward VII', she wrote, 'both my aunt and her own aunt, and two maids heard a great deal of noise in the cellar. She said it was just like furniture being moved about. They all spoke to each other about it and said they could not sleep well because of it, and then the papers announced the sudden illness of the King.' At around midnight on 6 May 1910, King Edward VII died, and a ghostly carriage drawn by four horses was seen leaving the yard. As Langston points out, this is odd as the king died at Whitehall Palace.

Brian Langston relates that Anne Groom's house in Park Street, which is situated close to the gates leading to the Long Walk, is haunted. Anne killed herself in 1891 after suffering abuse at the hands of a lover. She hanged herself from one of the

The Long Walk is haunted by the ghosts of 'Herne the Hunter' and a guardsman who had committed suicide.

bedroom windows on the top floor. Since then her spirit has refused to leave the house. Her presence is marked by an ice-cold spot right outside the front door. Witnesses have experienced a feeling of sadness and depression when approaching the house and some people have found themselves bursting into tears without explanation.

Another house in Park Street, known as 'Anne Foord's House, claims a number of hauntings. In the late 1930s a Colonel and Mrs Eliot rented and brought up their family in the elegant eighteenth-century house. The house is haunted by several ghosts including a monk who has woken up the lady of the house on several occasions by walking across the bedroom. On the first occasion she assumed it was her husband and sat up calling out 'is that you?' only to find her husband was still asleep next to her and heard the footsteps continue across the floor. Mrs Eliot heard them many times and whenever she did, she sat up and switched the light on but never saw anyone, although the footsteps continued diagonally across the room from an alcove beside the bed to the far wall where they stopped. Mrs Eliot believes the alcove was originally a doorway. She was never frightened at the footsteps and when her husband was away, she slept alone and frequently heard the footsteps while she was wide awake and reading with the light on.

The figure of a monk was once seen by the children and the nurse. One of the children recognised him as 'the nice old man who comes in to say goodnight'. When asked by his mother to describe him, her three-year-old son said, 'he's like Father Christmas – only wearing burnt paper'. Perhaps this was a reference to his hooded appearance in his black, coarse-textured habit. Mrs Eliot never saw anything but believed Thomas as a religious building stood on both sides of the house. One day the Colonel was showing an old gun to a friend who had some psychic ability. His friend declared that he could see a misty figure with a sort of white handkerchief over its head standing behind the Colonel. It was not until some years later that it was discovered the gun was a type used by the Foreign Legion.

Author Angus Macnaghten lived there as a child with his mother in 1937 and described in his book feeling that they both were being watched by an unseen presence. Although they never saw Thomas or the ghostly legionnaire, they were frequently reminded of a presence. Macnaghten and the family used to hear the sound of large objects being moved about on the top floor and heard the sound of a tinkling bell early in the morning.

Harte & Garter Hotel

High Street, Windsor, SL4 1PQ

The Harte & Garter is opposite the statue of Queen Victoria and was built on the site of the original Garter, one of Windsor's oldest coaching inns. An event occurred here which reminds us of the barbarity of English justice in times past. In the seventeenth

The ghost of a young ragged boy has been seen by visitors and staff.

century the inn housed one of the town's bakeries. In February 1629, an eight-year-old baker's assistant was accused of starting a fire which caused much damage. The child was tried, convicted, sentenced to death and hanged in Abingdon. The records show that a child was hanged for setting fire to two barns in Windsor. His ghost is reported to haunt the Harte & Garter, appearing as the ghost of a young ragged boy which has been seen by visitors and staff.

Drury House Restaurant

4 Church Street, Windsor, SL4 1PE

The Drury House in Church Street is popularly but inaccurately known as Nell Gwyn's house and is said to be haunted by her ghost. It was built in the reign of Charles I in 1645, originally to house staff from Windsor Castle. It was then rumoured to be part of the abode of Nell Gwyn, Charles II's favourite mistress to accommodate their secret liaisons. Nell never actually lived in the house. At that time, the street was called Fish Street and it was extremely pungent, being filled with fishmonger shops and butchers, all of whom would tip their waste onto the cobbles. Nell Gwyn preferred the more

One is an undertaker who is seen in a dining area on the second floor and the other is a young girl who plays on the stairs.

sumptuous surroundings of the Royal Mews round the corner, although she said she was happy for her maids to live there.

Although the Drury House may or may not house the ghost of Nell Gwyn, it does have two other ghosts. One is an undertaker who is seen in a dining area on the second floor and the other is a young girl who plays on the stairs. Murray Northwood from the Berkshire Paranormal Group reported that many people experience a ghostly chill in the room and he has had people who were so troubled by the presence on the second floor that they have refused to enter the room. The Drury House, a restaurant, was owned and run by Steve Turner and his family, all of whom had personal experience of mysterious happenings since taking over the business in 2013. Steve related, 'There's a mirror that distorts reflections even though it never moves, chairs that are left under tables that I pulled out in the morning, and two of the girls who work here have been tripped on the stairs when they were alone. Two weeks after I moved in, the head chef and I were the only ones left in the building and we were sitting on the ground floor when we suddenly heard a noise from the dumb waiter (a pulley system used to send trays of food up from the kitchen to the dining room). I went over and found two 50p coins on the floor – earlier in the day I had seen them on the second floor. I tried to dismiss it and not get worked up about it, but as I walked up the stairs, I found the two coins back on the second floor again. I dashed into my flat, locked the door and slept with the lights on!'

Market Cross House (The Crooked House)

51 High Street, Windsor, SL4 1LR

The original house was built in 1592, demolished and rebuilt in 1687. Because it was constructed using unseasoned green oak, it distorted over the years. It now has the reputation and local nickname the 'Crooked House'. Brian Langston tells us that for decades supernatural activity has been associated with the building.

In December 1997, a woman visiting from overseas, unfamiliar with the history of the house, entered the tearoom and stopped dead in her tracks. She announced to the staff, 'you have a female ghost don't you?'

Wendy Baines, who was working there at the time, was somewhat taken aback and answered hesitantly 'yes – we do have a ghost, but we always thought it was a man. How did you know?' The customer, who was clearly psychically gifted, looked around and pointed at the wall and said, 'when I came in I saw the figure of a woman standing there leaning over a fireplace rubbing her hands together as if warming herself in front of a cold fire'. The visitor went on to describe, in some detail, the figure she had seen. She was an old lady with grey hair in a bun with a long skirt and a high-collared blouse. As I looked at her she seemed to be aware of me looking and then turned slowly towards me and smiled before slowly disappearing. Wendy recalled, 'the hairs on my neck stood on end because this confirmed all the experience we had had over the years in the shop. The only thing which didn't make sense at the time was the fireplace because as far as we knew, where the customer had seen the ghost, was just a cupboard which we used to store crockery. Some months later

An old lady with grey hair in a bun, wearing a long skirt and a high-collared blouse, is one of the Crooked House hauntings.

we had to have some work done in the shop which uncovered a bricked-up fireplace behind the cupboard exactly where she had seen the woman warming her hands.'

Brian Langston goes on to observe that it is difficult to understand how the customer could possibly have known there was a fireplace at that location in the shop. It was not evident and even those who had worked there for many years had no idea of its existence. Wendy and her daughter Kerry, he tells us, went on to describe a catalogue of mysterious events which perplexed and spooked the staff who worked there. There had been many small things like a sink plug which mysteriously disappeared off its chain one day and was never seen again. They used to blame the ghost, which they nicknamed 'Harry', for being mischievous. Spoons disappeared by the dozen. Cafetieres and crockery jumped off shelves and smashed on the floor even though there was no one anywhere near them. Langston comments that there were two incidents which particularly scared Kerry and Wendy: 'One night before locking up we arranged the tables for the next morning and placed a little posy of artificial flowers on each of the tables. When we opened up the next morning every one of them had gone – we couldn't believe it as no one else had access to the premises.'

On another morning they opened up to find that the whole café was in disarray. They thought they had been burgled but there was no sign of a forced entry. There was tea spilt all over the floor, crockery smashed and the creepiest of all, the teapots were intertwined with spouts threaded through the handles, even though they been placed neatly on a shelf the evening before.

Old Windsor

St Peter and St Andrew Parish Church

4 Church Road, Old Windsor, SL4 2JW

This church is well worth a visit, with its large sprawling churchyard and interesting tombs. Angus Macnaghten in *Haunted Berkshire* tells us that both the churchyard and the adjoining private residence, the White Hermitage, are haunted. George IV, when he was the Prince Regent, had a mistress, Mary 'Perdita' Robinson, who died, crippled, and impoverished, at nearby Englefield Cottage. Her daughter, Maria Elizabeth, died aged eighteen in 1818. Both are buried in the churchyard. According to Macnaghten the daughter walks the graveyard in the early morning 'and at twilight, expressing her unhappiness'. He relates,

> whatever the truth of this story, one down to earth man had an uncanny experience when taking his dog for an evening walk. As he approached the wall of the churchyard, he saw a figure leaning against a wall. It seemed to be wearing a large hat, but he could not tell whether it was male or female. As he got nearer, he began to feel scared but at two yards from the wall the figure vanished. He never came across anything like that again, but a former vicar told him that the area was haunted and that he could never persuade his dog to walk past a nearby house, the White Hermitage.

A figure leaning against a wall wearing a large hat has been seen, which then fades away.

Above: The tomb of Mary 'Perdita' Robinson is in the foreground. Her daughter, also buried here, is believed to haunt the churchyard.

Right: A former vicar reported that he could never persuade his dog to walk past the White Hermitage which adjoins the church.

Acknowledgements

I would like to thank the following for their assistance: Aaron Jewell and Jim O'Connor of Bisham Abbey, Mel Harmes for providing invaluable local knowledge, Liam and the staff of 'The Ostrich' public house in Colnbrook, Sandra Steer for her many comments and assistance, Lesley Guinn for photos and company standing around in haunted graveyards, and Andrew and his team who provided an entertaining and informative tour of Windsor on a 'Windsor Ghost Tours' evening. (www.supernaturaltoursandevents.com).